NATIONAL GALLERY OF IRELAND

50 PICTURES

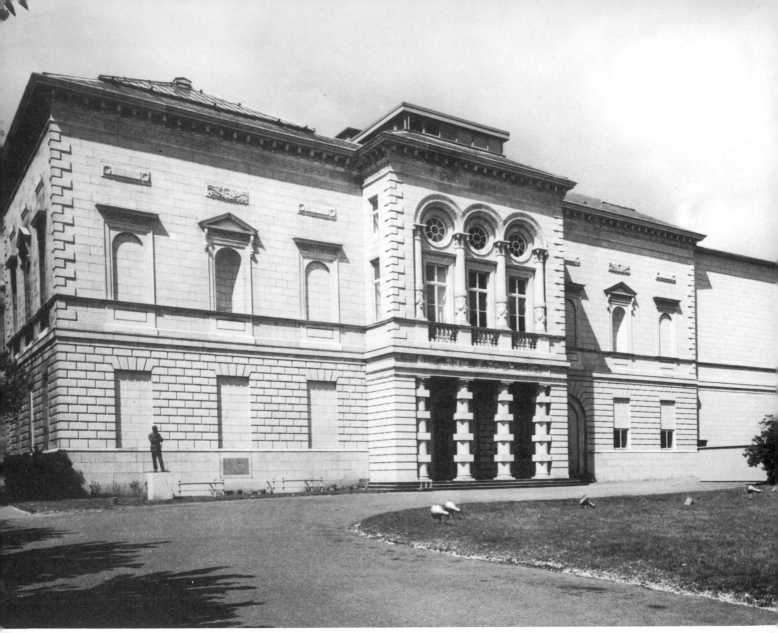

The National Gallery of Ireland

National Gallery of Ireland

50 Pictures

by Raymond Keaveney, Adrian Le Harivel, Anne Millar
and Homan Potterton

The National Gallery of Ireland 1981

50 PICTURES has been sponsored for the National Gallery of Ireland by Panelling Centre Ltd., 141 Lower Drumcondra Road, Dublin 9.

First published 1981 by the National Gallery of Ireland, Dublin 2.

50 PICTURES is distributed for the National Gallery of Ireland by Eason & Son Ltd., Dublin 1

ISBN 0 903162 05 9

Printed and bound in the Republic of Ireland by Cahill Printers Ltd., Dublin 3.

TABLE OF CONTENTS

THE NATIONAL GALLERY OF IRELAND

The National Gallery of Ireland first opened its doors to the public in March 1864, just over one month after its formal opening on 30 January of that year by the Lord Lieutenant, the Earl of Carlisle. The inauguration of the building brought to fulfilment an ideal which had been conceived as far back as 1766.

In that year, the Society of Artists, whose new home had just been completed in William Street, considered that in addition to a teaching academy a permanent gallery of pictures should be established in the city for the education of art students and the enjoyment of the public. Unfortunately, due to various difficulties, this project and subsequent similar schemes came to nothing. The seeds had been sown, nonetheless, and it was only a question of time before the expressed longing for a public picture gallery would come to fruition. All that was required was a suitable stimulus at a propitious moment.

The Great Industrial Exhibition held in Dublin in 1853 provided just such a stimulus. This momentous event, organised and financed by the rail magnate William Dargan, contained a number of cultural sideshows. The most remarkable and successful of these was an exhibition of Old Master paintings specially brought together for the occasion. The people's appetite for a public gallery was once again whetted and in November 1853 the Irish Institution was established. The Institution was founded 'for the promotion of Art in Ireland by the formation of a permanent exhibition in Dublin and eventually of an Irish National Gallery'. It held shows of the works of Old Masters, obtained chiefly from private collections in Ireland, and through the proceeds of those very popular exhibitions, and by way of gifts, it gradually acquired a number of pictures for the intended permanent collection.

Contemporaneously with the establishment of the Irish Institution a testimonial fund was set up to commemorate the public services of William Dargan, the genius behind the Great Exhibition. In 1854, the committee of this Fund voted £5,000 towards the erection of a public picture gallery to be called 'The Dargan Institute'.

The time was ripe, and on 10 August 1854 an Act of Parliament was approved 'to provide for the establishment of a National Gallery of Paintings, Sculpture, and the Fine Arts . . .' The Irish Institution was delighted with the news, while the committee of the Dargan Testimonial resolved to devote the £5,000 in their fund towards the founding of the National Gallery, provided a plaque commemorating the eminent public service of Dargan was set up inside the new building and a statue of him was placed outside the entrance.

In 1853, the Royal Dublin Society had resolved to erect extensive buildings to accommodate their Museum of Natural History on Leinster Lawn. The committee established in 1854 to consider the suitability of a location for the new National Gallery decided that Leinster Lawn was also the most convenient site for their purposes. The Royal Dublin Society agreed to allow the erection of the Gallery just across the Lawn from their own Museum, provided that its exterior architecture corresponded to that of their building.

The first stone of the new Gallery was laid on Leinster Lawn on 29 January 1859 by the Lord Lieutenant, the Earl of Eglinton and Winton. The designs were by Francis Fowke (architect of both Edinburgh's Royal Scottish Museum, and the South Kensington—later Victoria and Albert—Museum in London), and the cost of the entire project came to almost £30,000. In 1903 an extension to accommodate the Milltown Collection was added, designed by Sir Thomas Deane the Younger. The latest extension was opened in 1968; and already it seems desirable that further space should be provided for the display of the many beautiful paintings which still remain hidden in the underground stores.

The first purchase made by the Gallery consisted of a collection of 16 paintings bought in Rome in 1856. Eight years later, at the formal opening in 1864, the Gallery had 105 of its own paintings available for display to the public. These were supplemented by loans, and the total number of oil paintings which went on view was 188. Now, just over one hundred years later, the collection boasts over 2,200 paintings, almost 5,000 drawings and watercolours, 250 pieces of sculpture, and the Hunt Bequest of vestments and objets d'art, making it one of the finest and most representative collections in these islands.

Every major European school of painting is extensively represented in the Gallery's collection. There is also an important display of icons, and a room devoted to American painting. Not unexpectedly, an important display of Irish paintings is permanently on exhibition.

The Italian School, the largest in the Gallery, includes fine examples from almost every phase of its development ranging from the 14th to the 18th century. Among the artists are Andrea di Bartolo, Giovanni di Paolo, Fra Angelico, Perugino, Sebastiano del Piombo, Titian, Tintoretto, Veronese, Moroni, Lanfranco, Maratta, Castiglione, Strozzi, Guardi, Canaletto, Panini and Batoni.

The Dutch School covers every aspect of 17th-century Dutch art—portraits, landscapes, genre and still-life. Artists include Rembrandt, Jan Steen, Jan van Goyen, Salomon and Jacob van Ruisdael, Peter Claesz, Pieter de Hooch and Emanuel de Witte.

Considering our history, it is not surprising to find superb pictures from the British School on display in the Gallery. There is an outstanding group of canvases by Gainsborough, together with numerous portraits by Reynolds and other paintings by Hogarth, Wheatley, Stubbs, Wilson, Lawrence and Landseer.

The Spanish, German and French Schools, though smaller than those already mentioned, contain a rich selection of masterpieces. Artists represented include El Greco, Ribera, Zurbarán, Murillo and Goya; Conrad Faber, Cranach and Wolfgang Huber; and Claude, Poussin, Le Nain, Chardin, Desportes, David, Gérard, Delacroix, Courbet, Millet, Corot, Monet and Degas.

The Flemish paintings on exhibition cover a period of development of that School from the 15th to the 17th century, with works by Gerard David, Jan van Scorel, Marinus van Roymerswaele, Peter Paul Rubens, Jacob Jordaens, Anthony van Dyck and David Teniers the Younger.

Finally, the Irish School is represented by a selection of paintings which traces the development of Irish art from the 18th to the 20th century. All the outstanding personalities figure in the collection, among them James Latham, Nathaniel Hone the Elder, James Barry, George Barrett, Thomas Roberts, Francis Danby, Daniel Maclise, Nathaniel Hone the Younger, Walter Osborne and Jack B. Yeats.

Though the Gallery is state-funded, much of the collection has been acquired through the aid of private donations, gifts and bequests. The Milltown Bequest of 1902, for example, consisted of over two hundred paintings. Numerous masterpieces on display proclaim the names of the many generous benefactors, including Sir Hugh Lane, Sir Alfred Chester Beatty, and George Bernard Shaw, who left to the Gallery one-third of his estate.

In the West our image of the Virgin and Christ-child is conditioned by Renaissance pictures of a young mother with her plump baby (see No. 4). For the Byzantine artist of the 14th century they were still a somewhat daunting pair.

Pictures of the Virgin and Child increased after the Council of Ephesus in 431 confirmed that she was truly Christ's mother and not just a symbolic instrument. The most revered picture of them, supposedly painted from life by St Luke, was from the 6th century in the Hodegon monastery in Constantinople (today Istanbul). Known as the Virgin Hodigitria, it showed Mary pointing to her son as Saviour of the world. The composition is still reproduced today on the panel pictures (icons) attached to the iconostasis screen separating off the sanctuary in an Orthodox church.

This icon is said to have come from a now destroyed monastery at Trebizond (today Trabzon) on the Black Sea. The gold background is worn and the Virgin has lost her crown—once studded with jewels and enamels to judge by examples in St Mark's, Venice—but the figures still have a commanding presence. The faces are most detailed; subsidiary areas on an icon were often repainted or covered with metalwork. She is dressed in imperial purple reflecting the close links between the Byzantine church and State. The Old Testament prophets on the margin were added in the 15th century. The text on their scrolls refer to passages in their writings which foretold the coming of Christ. There are also visual symbols such as Moses's burning bush and Aaron's flowering staff.

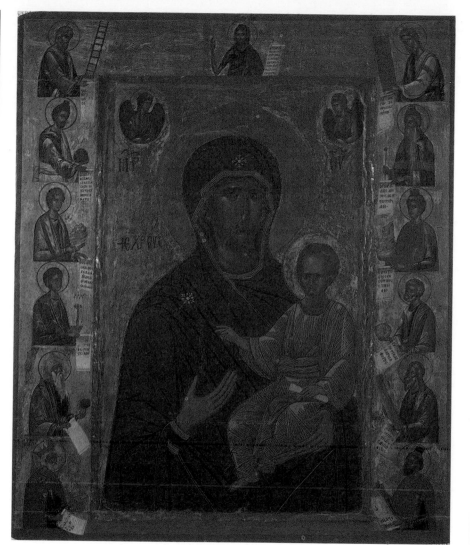

The Virgin and child Hodigitria, with on the margin St John the Baptist and twelve Prophets
CONSTANTINOPLE SCHOOL c.1325, with later margin
Tempera on panel, 135 × 111 cm. Purchased in 1968.

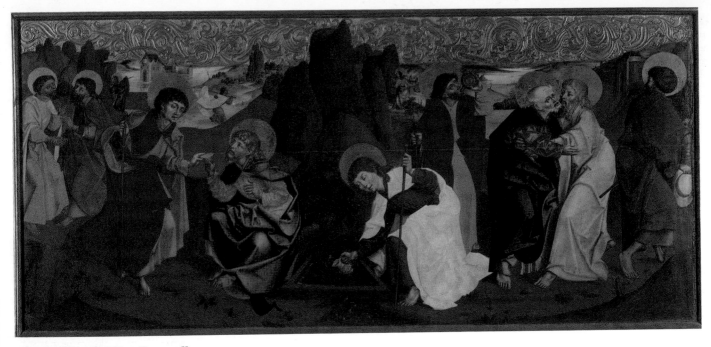

The Apostles bidding Farewell
STYRIAN SCHOOL, 15th century.
Oil on panel, 55 × 125 cm. Dated 1494 on reverse. Purchased in 1936.

The Styrian School of painting centred on Graz, now in south-eastern Austria. Artists were influenced by imported Flemish pictures, and by the work of local sculptors, who had close links with Burgundy.

The unknown painter of this panel began work with the gilded sky already inset: he had to overpaint it when adding distant mountains. Its relief pattern, of gold leaf laid on gesso, echoes the somewhat jerky movement of the figures of the twelve Apostles who are variously shown bidding each other farewell and setting out confidently with their tall staffs—a scene not described in the Bible.

They carry no symbols to identify them; St John (in the centre) can be recognised because of his youth. He is filling a *viertel* jug from a spring, and the artist takes delight in showing one Apostle drinking from a pilgrim bottle while another offers a companion a cup. He adds a moated castle in the background wilderness with no sense of incongruity; the city to the right, equally medieval, may represent Jerusalem.

The Apostles stand out in their richly coloured drapery, which falls with the sheet-like folds of late Gothic sculpture. There is great inventiveness in the poses of the figures and the angles from which they are seen. The artist may have known a now lost picture of this subject by Albert van Ouwater. The Flemish painter would have found the haloes and the partially stylized landscape rather strange, but there is a marvellous rhythm to the figures and the varied colours have an enamel-like intensity.

Giovanni di Paolo enjoyed a long career in Siena from about 1426, with sufficient energy to re-marry aged 70. His present reputation owes much to the researches of Bernard Berenson, who authenticated this picture in 1955, while still under discoloured varnish.

This savage *Crucifixion*, one of the most moving works in the Gallery, was painted in the 1440s for an unknown Sienese church, where it would have hung above the entrance to the choir. (Painted Crucifixes, with their appeal to the emotions of the worshipper, were by then thought rather old-fashioned in nearby Florence). Later cut down and made into a rectangular composition, its original appearance has now been restored. The terminals would have contained figures of the Virgin (left) and St John (right), with perhaps a pelican feeding its young with its own blood (above), an analogy of the Crucifixion.

Christ is shown in the traditional way, with halo, crown of thorns, and the label 'I.N.R.I.' (standing for 'Jesus of Nazareth, King of the Jews'). Blood spurts from the lance wound, and his body sags forward, barely supported by a foot-rest (an invention of Medieval artists). Giovanni di Paolo stresses the horror of the nails, the streaming blood, and the pathetic crushed toes, yet the fall of the body has a strange beauty. When the picture was transferred to its present support, powerful underdrawing could be seen; the more stylized painted figure may be a concession to Sienese taste, like the swooning angels engraved in the gold background, one of whom is catching Christ's blood in a chalice.

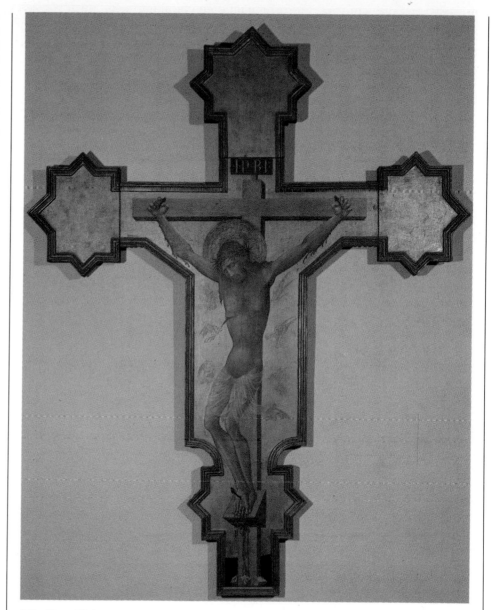

The Crucifixion.
GIOVANNI DI PAOLO, c.1403-1483.
Tempera on panel, 163 × 99 cm (216 × 170 cm with restored terminals).
Purchased in 1964.

4

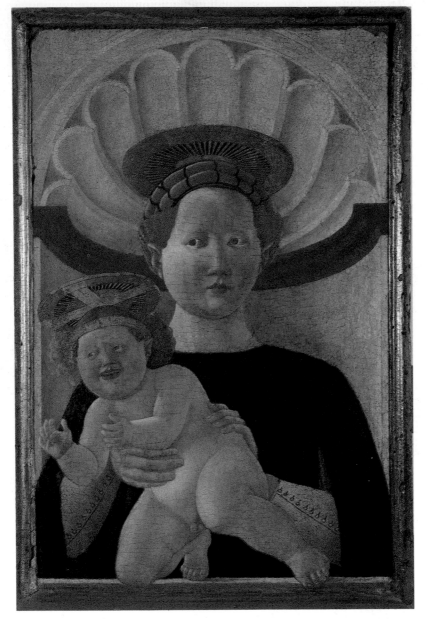

Virgin and Child.
PAOLO UCCELLO, 1397-1475.
Tempera on panel, 58 × 37 cm. Purchased in 1909.

One of the most fascinating personalities in 15th-century Italian art, Uccello started his career in the workshop of Lorenzo Ghiberti in Florence, where he may have assisted in the creation of Ghiberti's first set of bronze doors for the Baptistery. His master's blending of the older decorative International Gothic and the new revolutionary rational art forms of the Renaissance greatly impressed the young Uccello, who in his mature works combines the fanciful decorative qualities of Gothic art with the mathematical precision and skill of perspective drawing.

The subject of the Madonna and Child goes back to the origins of Christian art, to a portrait reputedly painted by St Luke (see No. 1). Uccello here gives it an almost secular quality, turning it into a game of perspective. The two figures are set against the simple backdrop of a niche. Their features are not treated naturalistically, but are reduced to simple forms, the head of Christ being inscribed in a circle while that of the Virgin is shown as an oval. The haloes are seen purely as cleverly drawn metallic discs. The infant Christ, instead of clinging to his mother or making a gesture of benediction towards the observer, appears to step playfully across the picture plane into the space of the viewer.

At some later date the Virgin was given a dark veil, perhaps to make her appear more dignified. This overpainting was removed during restoration in the late 1960s, and Uccello's image returned to its pristine and slightly shocking appearance.

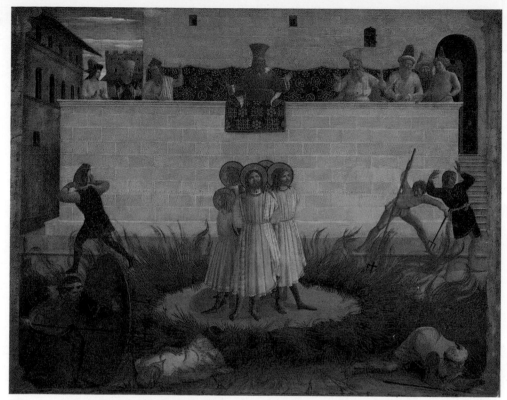

The Attempted Martyrdom of SS. Cosmas and Damian with their Brothers.
FRA ANGELICO, 1387-1455.
Tempera on panel, 36 × 46 cm. Purchased in 1886.

Fra Angelico, one of the greatest painters of the early Italian Renaissance, was a Dominican friar attached to the Convent of S. Marco in Florence, for which this picture was painted.

Cosmas and Damian were twin brothers who, as physicians in Syria in the 3rd century, gave their services free in order to make converts to Christianity. Refusing to sacrifice to idols, they were condemned to death by Proconsul Lysias. They survived many attempts on their lives, including the one shown here, when Lysias (on the balcony behind them) ordered them, together with their three brothers, to be burned at the stake. The flames of the fire spread outwards, leaving them unscathed, and instead forced their executioners to flee. Cosmas and Damian were especially invoked against sickness and the plague, and were patron saints of the Medici family in Florence.

This scene, painted probably between 1438 and 1440, is from the altarpiece for the high altar. It is one of the *predella* panels—small pictures at the base of an altarpiece—of which others are in Washington, Munich, Florence and Paris. The main subject was *The Virgin and Child enthroned with Saints*. Although very simple, the composition is carefully planned, with the foreground, middle distance and background clearly defined. This effect of spatial depth is enhanced by the line of the street leading into the picture on the left and the mounting stairs on the right. In his concern with spatial perspective Fra Angelico reflects one of the principal preoccupations of his contemporary artists in Renaissance Florence.

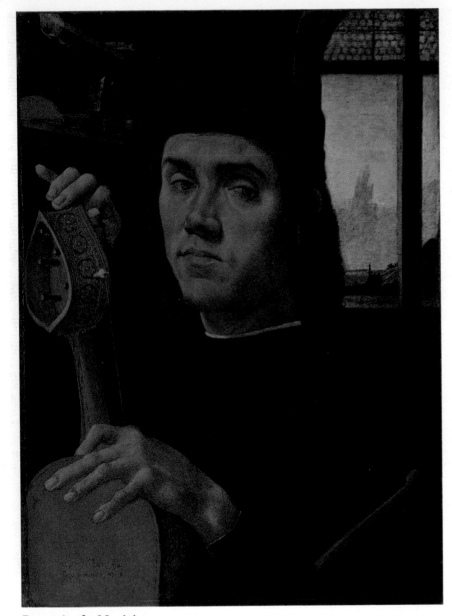

Portrait of a Musician.
FILIPPINO LIPPI, 1457-1504.
Oil on panel, 51 × 36 cm. Purchased in 1897.

Filippino Lippi was the son of the artist Fra Filippo Lippi and Lucretia Buti, an Augustinian nun. He received his earliest training from his father and may have entered the studio of Botticelli to finish his training. His mature style, nervous, agitated and dynamic, frequently verges on the bizarre.

The art of portraiture made great advances during the Renaissance. In the early Quattrocento the portrait was conceived as a simple likeness and the sitter was usually shown in profile. Later in the century artists began to explore the possibilities of imparting a more complex and lifelike quality to their portraits, which would convey aspects of the personality of their patrons.

This is precisely what Filippino Lippi has achieved in this painting. The portrait is dramatised and brought to life by the simple yet novel device of representing the young man not simply posing to have his likeness painted, but actively engaged in preparing himself for a musical performance. His finely drawn features, quiet pensive gaze, and delicate fingers engaged in tuning his *lira da braccio*, convey the impression of a sensitive, intelligent and cultured personality. Though we do not know his identity, it is likely that he was a well known musician and composer of the day. The inscription 'e ichonjcar no fia p tempo mai' ('and it will never be too early to begin') which can be seen in the bottom left hand corner of the picture may be a verse from a song which he composed, or it may refer to his own keenness to finish tuning his instrument and begin playing.

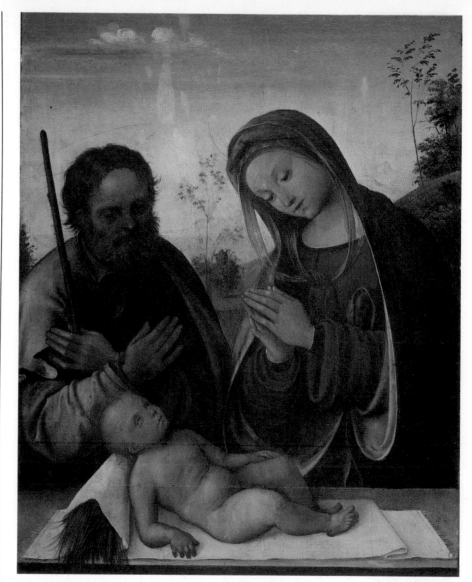

Costa was born in Ferrara and later moved to Mantua, where he lived for the last thirty years of his life, dying, the records tell us, at the age of 75. During the second half of the 15th century, Ferrara became one of the most important cultural centres in Italy. A local school of painting developed there which had as its most characteristic exponent the bizarre genius Cosimo Tura, and in his studio Costa may have received his first instruction.

Costa's art is representative of the substratum of Italian art during the High Renaissance: while the outstanding personalities were charting new areas of human experience and expression they were being carefully watched by lesser masters, who broke down the complex new style into more easily comprehensible and readily reconstructible formulae. Thus his art like that of many of his contemporaries, frequently tends to be dry, eclectic and lacking in originality.

What Costa lacks in invention and expression he makes up for in the charming simplicity, almost naïveté, of his compositions, with their delicate and delightful colouring, and lyrical feeling. *The Holy Family*, probably painted c.1504, is typical. It is a devotional image, intended for use in a home rather than in a church. The composition is simple in the extreme, enhancing the overall feeling of piety and humility which is engendered by this reverent depiction of the Virgin and St Joseph standing in silent prayer before the infant Christ.

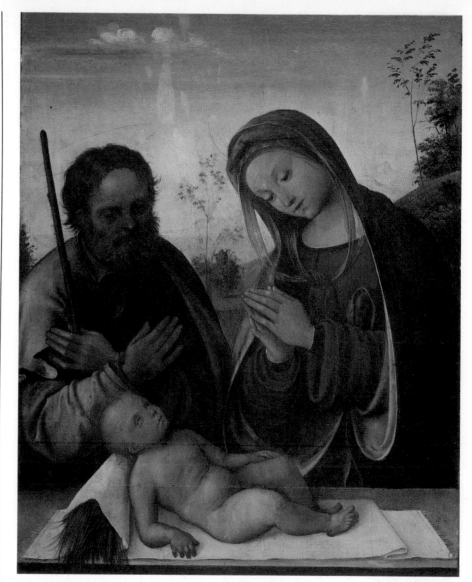

The Holy Family.
LORENZO COSTA, c.1460-1535.
Oil on panel, 71 × 55 cm. Purchased in 1901.

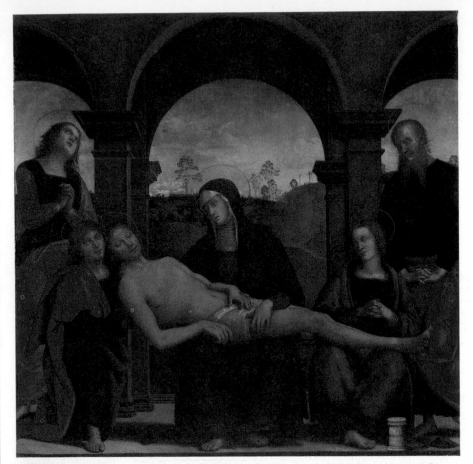

The Pietà.
PIETRO VANUCCI, called PERUGINO, 1446-1523.
Oil on panel, 169.5 × 171.5 cm. Inscribed 'PETRUS PERUSINUS PINXIT'
Purchased in 1931.

Perugino began and ended his life in Perugia, from where his name is derived. He was reputedly trained by Piero della Francesca, and received important commissions in Florence and Rome. His best known pupil was Raphael. In this *Pietà*, or lamentation over the dead Christ, painted in the 1490s, Perugino imagines the scene prior to the burial of Christ. The centre is dominated by the Virgin Mary, who supports her son's body on her knees. His head rests against St John's shoulder, his feet on St Mary Magdalen's knees. Behind are the Pharisees Nicodemus (left), and Joseph of Arimathea (right) who gave the tomb in which Christ was buried. A distant landscape is filled by the golden light of the setting sun, which makes silhouettes of trees and the last spectators leaving the crosses on Golgotha.

The arched setting suggests the threefold division of earlier altarpieces. Its austerity is echoed in the simple robes of the figures and their bare feet. The muted colour scheme is broken only by Nicodemus's brocade and the Magdalen's pot of ointment, placed on the edge of the picture space. Perugino seems to have been unable to express violence and pain in his work: his quiet, pious outlook is reflected in the idealised features and deeply moved expressions of his figures. He intended this picture (of which an earlier version, dated 1495, is in Florence) to induce tranquil meditation on the Passion.

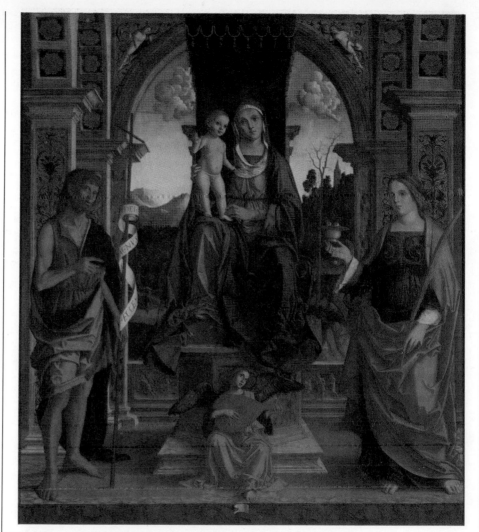

Palmizano was born in Forlì, between Florence and Ravenna. He was a pupil of Melozzo da Forlì, and he followed his master's style so closely that problems of attribution have arisen. This work is signed and dated 1513 on the small scrap of paper illusionistically pinned to the marble step at the lute-playing angel's feet.

The Virgin is seated on a high, canopied throne which identifies her as the Queen of Heaven. The saints are grouped with her in the imagined space, forming a scene known as a *sacra conversazione*, or 'holy conversation'. St Lucy is an elegant and holy companion to the Virgin. She carries her palm of martyrdom, and her eyes, which according to tradition she plucked out and sent to her lover when he was incessant in praising their beauty. St John is the protector of the Virgin; he points to the young Saviour, proclaiming '*Ecce Agnus Dei*' ('Behold the Lamb of God') with his scroll. The young Christ shakily stands erect, holding the Virgin's girdle for support, a detail which suggests the tender intimacy between mother and child.

This painting, with the landscape framed by architecture, has strong links with the Venetian artist Giovanni Bellini, while the Classical reliefs behind the throne, and the hard, precise light which falls evenly on all textures, show the influence of Mantegna (see No. 10).

Virgin and Child enthroned, with St Lucy and St John the Baptist.
MARCO PALMIZANO, 1458-1539.
Oil on panel, 218 × 188 cm. Inscribed 'MARCHUS PALMIZANUS PICTOR [F]OROLIVI [ENSIS] FECIT MDXIII': Purchased in 1863.

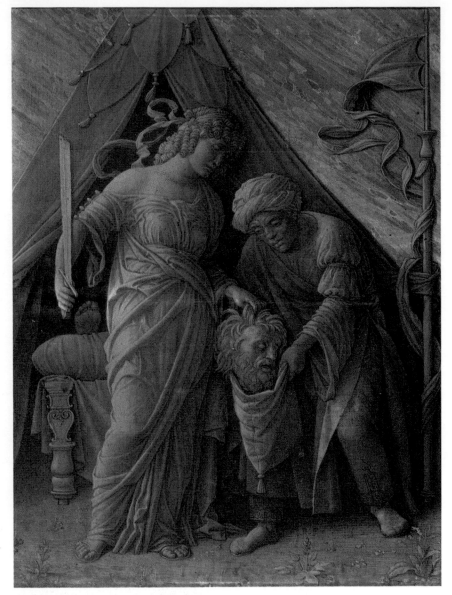

Judith with the Head of Holofernes.
ANDREA MANTEGNA, 1431-1506.
Tempera on linen, 46 × 36 cm. Purchased in 1896.

Mantegna spent his youth in Padua, and then lived mainly in Mantua, where he became court painter to the Gonzaga family in 1456. Although detached from the sphere of Florentine painting, his work was enormously influential.

The subject of this picture is taken from the Apocryphal Book of Judith. When the city of Bethulia was besieged by the Assyrians, the Jewish heroine Judith pretended to desert her people and, accompanied by a maid, visited the enemy general, Holofernes, in his camp. Seduced by her beauty, Holofernes invited her to his tent where Judith, having lulled him to sleep, decapitated him, and then carried his head away in a sack. The Assyrians, alarmed by the loss of their leader, lifted the siege and fled. The subject was intended to represent the triumph of good over evil.

Vasari in his life of Mantegna, published first in 1550, wrote that he always held that the fine statues of Antiquity were invariably more perfect than nature, and that he applied this principle to his work 'so that his figures sometimes seem to be made of stone rather than flesh and blood'. This picture, which is painted in grey monotone to simulate marble, is an example of that aspect of Mantegna's style. It also reveals the artist's preoccupation with the effects of illusion; the figures are painted as though seen from below, and the sense of depth is conveyed not through perspective but by means of such devices as the darkened opening of the tent, and, more dramatically, the sole of Holofernes's foot (visible to the left of Judith).

The Master of the St Barbara Legend worked in Brussels during the last third of the 15th century. His name comes from a triptych in Brussels showing the life of St Barbara, the largest of several anonymous works which Friedländer attributed to one master. He is an interesting figure, as his realism shows the precision with which even minor artists worked in 15th century Flanders. It was a skill noted by Michelangelo, who said: 'In Flanders they paint . . . to render exactly and deceptively the outward appearance of things.' His style, however, is angular and slightly crude in its expression. The faces of the figures have a certain exaggeration, either of sentiment or of harshness, and he lacks the sophistication and finesse of van der Weyden and Bouts, two contemporaries who influenced him most strongly.

St Nicholas was Bishop of Myra in Asia Minor in the 4th century, and his saintly life was marked by many miracles and deeds of kindness. The *Golden Legend* by Jacobus de Voragine, the most important medieval source for the lives of saints, tells of a man who, while owing money to a Jew, was run over and killed by a chariot. St Nicholas restored him to life, and the Jew was converted to Christianity. Another story tells how St Nicholas brought back to life three children who had been killed and salted down as food.

Following an archaic narrative style, the Saint is shown here twice, raising the dead man and baptising the three children. The bearded figure in the pointed oriental hat is the Jew.

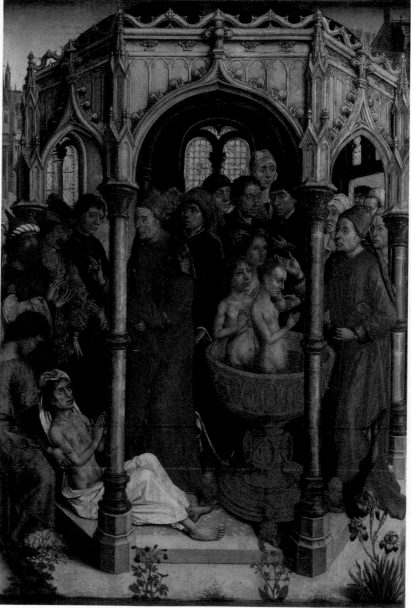

The Miracles of St Nicholas.
MASTER OF THE ST BARBARA LEGEND, active c.1470-1500.
Oil on panel, 97 × 66 cm. Purchased in 1862.

The Rest on the Flight into Egypt.
ADRIAEN VAN IJSENBRANDT, active 1510-1551.
Oil on panel, 37 × 30 cm. Purchased in 1900.

Ijsenbrandt was the only documented pupil of Gerard David in Bruges; like him he was not a native of the city, but his birthplace is unknown. Ijsenbrandt entered the Guild of Painters in 1510, was its Treasurer in 1526 and 1535, and had the honorary title of Master in the Guild's obituary.

This painting's subject was identified because of its close similarity to a *Rest on the Flight into Egypt* by David (in Washington). There are various subtle changes between the two compositions: David's Child is clothed in preparation for the journey, whereas Ijsenbrandt's child wears only in a flimsy veil; holding a bunch of grapes symbolic of the Passion, he is more suggestive of Christ on the cross. The Virgin, seated on a low stony bank, tenderly holds the Child, while her dark drapery is protectively tent-like.

The subject was a popular one in Flemish painting as it combined two of the major themes in Northern art—the landscape and the devotional image. The subtle tones and misty distances of Northern landscapes enhanced the solitude and emotion of the devotional image, which was recognised by Michelangelo: 'Flemish painting pleases the devout better than Italian. The latter evokes no tears, the former makes them weep copiously.' Northern painting evolved from the highly detailed and elegant tradition of illuminated manuscript painting. Flemish artists were renowned for their mastery of the oil technique, using the delicate glazes to portray realistic detail and the effect of light on different surfaces and textures.

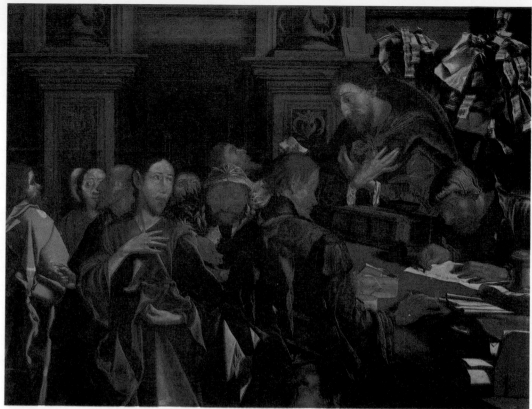

The Calling of St Matthew.
MARINUS VAN ROYMERSWAELE, 1497-1567.
Oil on panel, 83 × 109 cm. Purchased in 1944.

Roymerswaele was born in Zeeland, a province south of Holland annexed by Burgundy in 1433. He was in the studio of the Antwerp stained-glass painter Simon van Daele by 1509. In 1567 he was fined and exiled for six years after a conviction for iconoclasm in a church in Middelburg. He specialised in caricatures of tax collectors of a type made popular by the Antwerp painter Quentin Metsys, with whom he is often confused. Antwerp in Roymerswaele's lifetime was the major port in Northern Europe; imported Italian pictures vied for attention with those of Flemish artists, who (like Flemish architects) tended to incorporate Italianate details while continuing the traditions of the 15th century.

Here we see the crowded tax office in Caphernaum, where the fifth disciple, Matthew, was called by Christ from his job as tax collector. Across the centre the eyes of Jesus and Matthew meet. Business continues undisturbed, and even the other disciples seem unaware of what is going on.

Roymerswaele disconcerts the spectator with his lack of symmetry, and by turning the heads in every direction. The convincing detail of the foreground tax collector contrasts with the oversize St. Matthew. Drapery, hair, and the spindly fingers are charged with energy. Even the seals on the wall seem animate. The elaborate Renaissance architecture with stage-like recession is probably taken from a book of engravings. While Jesus and Matthew are involved in a mystical drama, the detail of a man carefully counting his change, and the relaxed figure to the right awaiting a receipt, are reassuring reminders of everyday life.

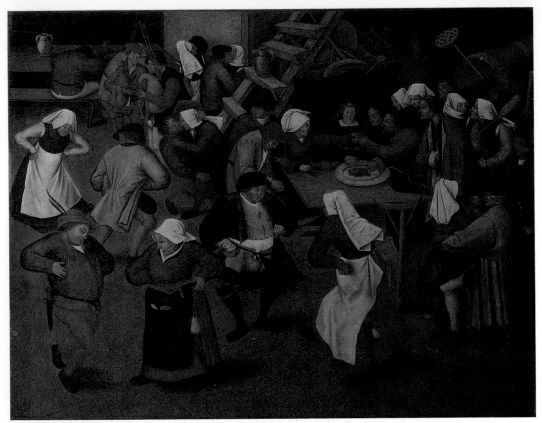

A Peasant Wedding.
PIETER BRUEGHEL THE YOUNGER, 1564-1638.
Oil on panel, 84 × 112 cm. Inscribed 'P. BREGHEL 1620'
Purchased in 1928.

Pieter Brueghel the Younger, who was born in Brussels and died in Antwerp, was the son of a more famous painter of the same name, and frequently copied or derived his pictures from his father's work, as here. A celebrated painting of *A Peasant Wedding* by Brueghel the Elder (now in Vienna) shows a bride very similar to the woman in this painting.

The bride, wearing a crown, is seated behind the table, and peasants place their contributions to her dowry on the platter in front of her. The scene takes place in a barn: there are a number of farm implements in the background. Several elderly couples are dancing to the music of bagpipes, with a more than usual degree of licentiousness. An argument has broken out between one of the guests and the bride's mother, who is apparently demanding a more substantial contribution. The top of the table is incised with rough carvings of an owl, a windmill, a heart with crossed arrows and fish. These, on first glance, appear to be merely doodles, but they are all carved to face the spectator, and one may be fairly certain that they are intended to convey a message. Of the seven deadly sins, lust, wrath and greed are the three most prominently highlighted in the scene portrayed, and Brueghel probably points a moral as to their iniquities. This apparently simple low-life scene thus has a moral and a meaning, the full extent of which today often eludes us.

Cranach was born in Franconia. After spending several years in Vienna, he entered the service of the Elector of Saxony at Wittenberg in 1505. His Viennese style was highly coloured and powerfully emotional, but at the Elector's court he soon began to paint in an increasingly restrained and sophisticated manner. His technique became more smoothly finished, and perfectly suited to the depiction of decorative costume detail and delicate skin tones. At Wittenberg he became obsessed with a highly personal ideal of female beauty. He developed a formula of elegantly dressed young women, heavy with golden jewellery, who despite their charming naïveté are compellingly sensual. Cranach's style altered little during his lifetime in Wittenberg. His graceful heroines and disquietingly un-Classical nudes evoked a wholly Germanic cultural past which was recognised and identified with at the Saxon court.

The Jewish heroine Judith was a popular figure in 15th- and 16th-century painting (see No. 10). She formed the female parallel to David, representing the triumph of youthful innocence over corrupt strength. In this painting Judith holds the severed head of Holofernes and the heavy naked blade with a disturbingly passive sophistication.

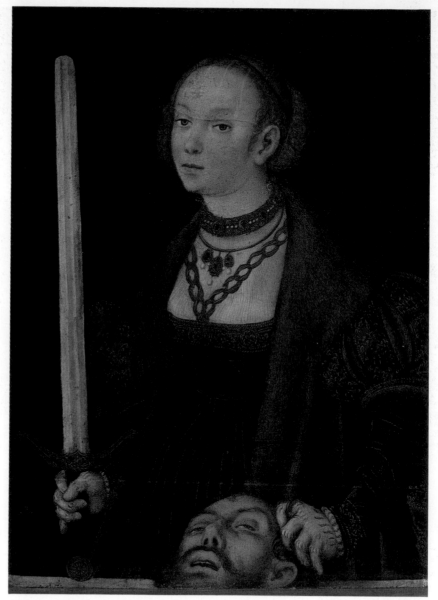

Judith with the Head of Holofernes.
LUCAS CRANACH THE ELDER, 1472-1533.
Oil on panel, 44 × 31 cm. Inscribed with Cranach's device, a crowned dragon. Purchased in 1879.

16

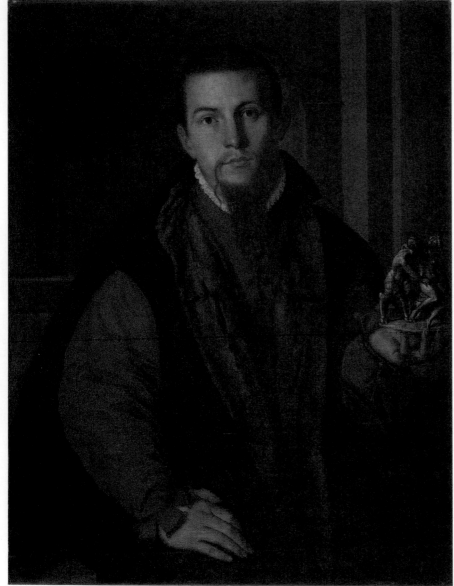

Portrait of Georg Vischer.
GEORG PENCZ, *c.*1500-1550.
Oil on panel, 86 × 66 cm. Inscribed 'AETATIS S XXVII 15 GP 49'.
Purchased in 1864.

Pencz was a pupil in Nuremberg of the most famous of all German artists, Albrecht Dürer. He and two other pupils, described as 'three Godless artists', were expelled from the city in 1525 for refusing to acknowledge the authority of either Church or State. About this time he went to Italy, where he may have remained for more than a decade. Pencz was influenced by Dürer, but more important to him was his experience of Italy. This portrait is Italianate in its presentation of the figure in three-quarter-length, in the self-confident ease of the sitter as he gazes directly outward, and in its scale: it is much larger than most German portraits of the time.

The inscription records that the sitter was 27 years old. He holds a sculpture representing Pan seducing Luna, which is painted grey to suggest that it is a sculptor's model, and he has been identified as Georg Vischer, the last known member of a famous Nuremberg family of sculptors and bronze-founders, who became master of the family foundry in 1549, the date when the picture was painted. Although the sculpture he holds is unknown, it is similar in style to his work.

In Ireland and Britain the mid-19th century saw a revival of interest in early German painting. This portrait was purchased in the year when the Gallery first opened to the public.

Born near Bergamo in northern Italy, Moroni had his earliest training under Moretto in Brescia. He was profoundly influenced by Moretto's powerful compositions, populated with figures simply conceived and lit so as to emphasise their solid forms and the rich colour and texture of their garments.

In the 16th century Venice was the ruling power over much of Lombardy, controlling Brescia, where Moroni spent the greater part of his early career, and Bergamo where he passed the final phase of his life. Portrait painting in this society was principally concerned with naturalistic depictions of the local aristocracy and business community, rather than the sumptuous images of patricians called for in Venice itself.

This portrait of a gentleman and his two children, also known as *The Widower*, is a fine example of Moroni's relaxed and sympathetic approach to his subjects. The father, soberly dressed in black, is placed against a simple background, carefully modulated in grey-blue tones. He gazes wistfully at the onlooker, while his outstretched arms protectively embrace his two small children, delicately and enchantingly portrayed in their yellow, green and faded crimson garments which contrast wonderfully with the subdued monochrome of the rest of the picture. On the table at the man's side a letter is visible in which the word 'Albino', the name of the artist's home town, can be deciphered. The composition, a group portrait, is unusual for Moroni, as are the images of the two children, a subject he rarely painted.

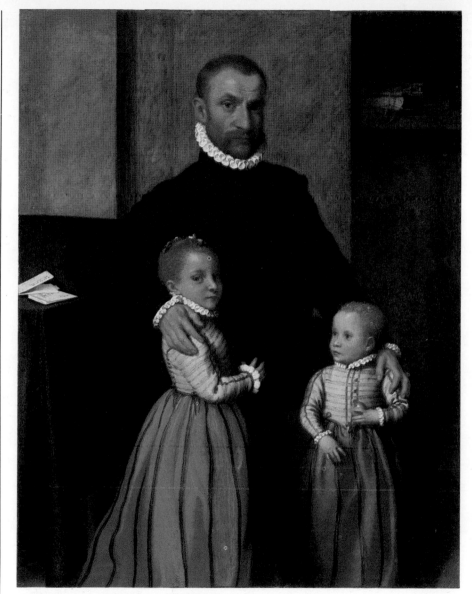

A Gentleman with his two Children.
GIOVANNI BATTISTA MORONI, *c*.1520/25-1578.
Oil on canvas, 126 × 98 cm. Purchased in 1866.

18 | Titian was a Venetian and perhaps the greatest painter of the Italian High Renaissance. He is supposed to have lived to the age of 99, but it is more likely that he was about 86 when he died. Because his working life was long, his style changed considerably, from the brightly coloured and carefully contoured works of his youth to the more sombre and moving images of his last decades. In those pictures he 'drew' the design directly on the canvas with the brush, and from these broad areas of colour worked up the finished composition.

After the Crowning with Thorns the soldiers put a purple robe on Christ and Pilate brought him before the crowd, saying, *'Ecce homo'*—'Behold the man'. The crowd responded 'Crucify him', and Pilate condemned him. Christ is here represented as a king wearing the crown of thorns and holding the sceptre made from a reed; his wrists are bound. In fulfilment of the prophecy of Isaiah, he is 'a man of sorrows and acquainted with grief'.

This image of Christ, which is a devotional rather than a narrative one, was more popular with painters in the 16th century than at any other time, and Titian painted the subject on a number of occasions. The Gallery's picture is accepted as authentic, and was probably painted about 1560, that is relatively late in Titian's career. It may once have been owned by Van Dyck.

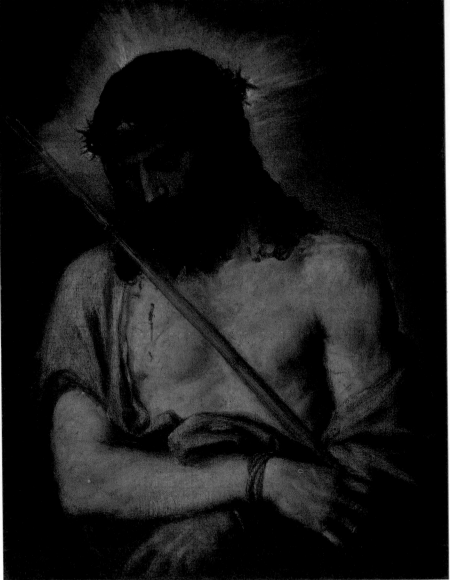

Ecce Homo.
TIZIANO VECELLI, called TITIAN, *c*.1480-1576.
Oil on canvas, 72 × 55 cm. Purchased in 1885.

A native of Verona, as his nickname indicates, Veronese spent his life in Venice and the Veneto. His figures tend to be somewhat static, and his speciality was religious events set against a vista of imaginary palaces.

St Philip (right) was one of the first disciples. While preaching at Hierapolis he was said to have exorcised a dragon which protected a temple dedicated to Mercury, and could kill just by its smell. His cross here alludes to the belief that he was crucified upside-down like St Peter. He is the patron saint of Sorrento. St James the Less (left) was a brother of Christ, according to St Paul, and the first bishop of Jerusalem. His similarity to Christ (evident here) may explain why Judas had to identify Christ by a kiss in Gethsemane (see No. 22). Early sources say that James was thrown from the roof of the Temple in AD 62, and beaten to death. The *Golden Legend* adds that a fuller's staff was used to kill him. He was later the patron saint of hatmakers, and his head was once a relic in Ancona Cathedral.

Veronese presents the saints as strong-limbed and confident. Their richly painted skin and draperies reveal his Venetian training. The play on diagonals and the foreshortened cross enliven the scene, but Veronese lacks the skill of Titian to give a spiritual dimension to the saints. Ridolfi in 1648 mentions this picture as being in Lecce, a town in the heel of Italy, where it may have hung in a chapel of the Venetians' church. More information about the original owner might explain the choice of these two saints and the appearance of an angel in the sky.

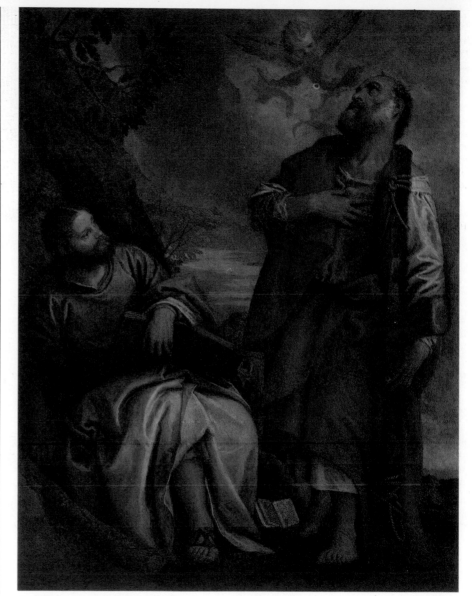

St Philip and St James the Less.
PAOLO CALIARI, called VERONESE, 1528-1588.
Oil on canvas, 204 × 156 cm. Purchased in 1889.

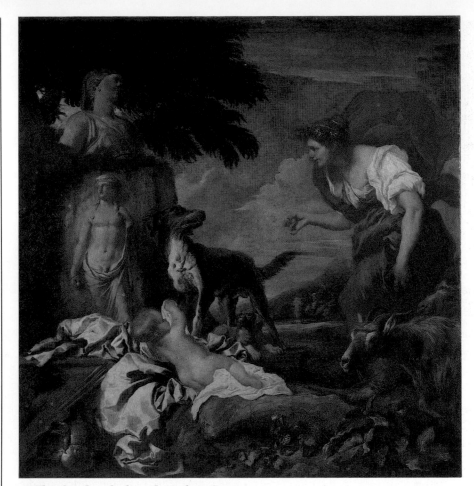

A Shepherdess finding the Infant Cyrus.
GIOVANNI CASTIGLIONE, 1616-1670.
Oil on canvas, 232 × 226 cm. Purchased in 1937.

Castiglione was trained by the minor painter Paggi in his native city of Genoa, where he could have seen pictures by the leading seventeenth century Italian and Flemish artists. In the 1650s, when this picture was painted, he was working in Mantua for the Gonzagas, patrons a generation earlier of Rubens.

The Median King Astyages had an ominous dream that his grandson, Cyrus, would one day overthrow him. A shepherd was instructed to leave the child to die on the mountainside, but unwittingly adopted it, when his wife replaced Cyrus with her still-born baby. Many years later Cyrus ousted his grandfather, and founded an empire that stretched from Babylon to Palestine. The story was popular for its parallels with those of Romulus and Remus and the finding of Moses.

Castiglione illustrates the dramatic moment of Cyrus's discovery, but with none of a Victorian painter's concern for authentic detail. A refined young girl, loosely dressed in billowing satin, with pearls and flowers in her hair, comes upon Cyrus in a verdant landscape. The infant lies beneath Roman statuary (probably from the Gonzaga collection), with a symbolic helmet and quiver of arrows beside him. The light palette and ordered composition reflect the influence of Poussin (see No. 24). There is a fine preparatory drawing at Windsor which belonged to Joseph Smith, the English Consul in Venice (best known for his patronage of Canaletto) in the eighteenth century, when Castiglione's work was eagerly collected.

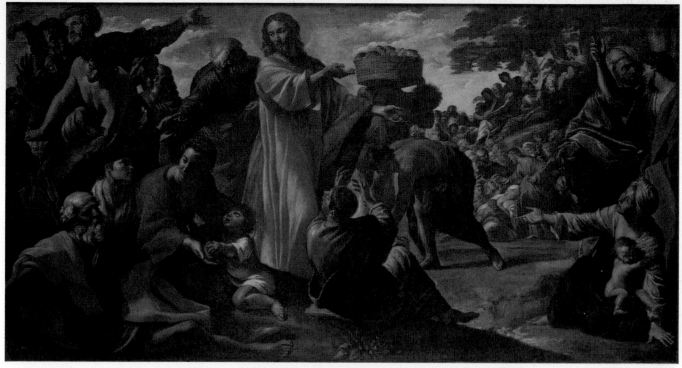

The Miracle of the Loaves and Fishes.
GIOVANNI LANFRANCO, 1582-1647.
Oil on canvas, 229 × 426 cm. Purchased in 1856.

Lanfranco was born in Parma, and after a brief period in Piacenza he entered the studio of Agostino Carracci in Bologna. By 1602 he was in Rome, where he worked in the Palazzo Farnese under the direction of Annibale Carracci. His style was thus shaped by Correggio, whose most famous work was in Parma, and by the Carracci.

This picture and *The Last Supper*, which hang together in the Gallery, were the central canvases of a large decorative scheme for the Chapel of the Blessed Sacrament in S. Paolo fuori le Mura in Rome, begun in 1624, which represented biblical events where man had been nourished by God's grace. The Blessed Sacrament was a popular subject in Baroque painting: the idea of the Real Presence of Christ in the Eucharist had been one of the most severely attacked tenets of Catholic doctrine during the Protestant Reformation, and the dramatic exuberance of the Baroque style was used to promote Counter-Reformation dogma.

In the painting Christ directs the distribution of the loaves and fishes, assisted by St Philip—whose dark curly hair and boldly shaded nude torso recall the work of Caravaggio—and the white-haired St Andrew. Lanfranco is combining two important aspects of the Roman Baroque style: gesture and elaborate composition. With its arresting colour this painting contrasted dramatically with the dark, mystical *Last Supper*, which hung on the facing wall of the chapel.

The Betrayal of Christ.
MATTHIAS STOMER, *c.*1600-after 1650.
Oil on canvas, 201 × 279 cm. Presented by Sir George Donaldson in 1894.

Stomer was born in Amersfoort and was a pupil of Honthorst. In the newly independent Netherlands some artists developed the naturalism now thought of as typically Dutch, but others, including Stomer, looked to Italy for inspiration. This picture dates from about 1630 when he was in Rome.

In 1631 he left the city, and from then until his death he led an itinerant life in Naples and Sicily painting the occasional altarpiece. He had no impact on Italian painters, who must have thought him rather old-fashioned, but his ideas found an attentive audience back in Utrecht.

Stomer's picture, with its lifesize figures, shows Christ in the Garden of Gethsemane immediately after his arrest, not the more usual incident of Christ being kissed by Judas. Judas's head may be the central one, half lost in shadow. The twisted foreground figure is Malachus the High Priest's servant; St Peter has drawn a sword and is about to cut off his ear. The influence of Caravaggio is strong, especially in the emphasis on muscular figures, torchlit against a sketchy background. This is one of Stomer's finest works, in which the violent expression of the central soldier (in 17th-century dress) and the mass of converging figures contrast with the quiet accepting expression of Christ.

As recently as 1950 the picture was thought to be by a Neapolitan artist because of its dramatic use of *tenebroso* and the leathery skin texture of the figures. It owes much to engravings (especially those of Goltzius and Dürer), and there are sketches by Van Dyck and Jordaens of the same theme that Stomer may have seen.

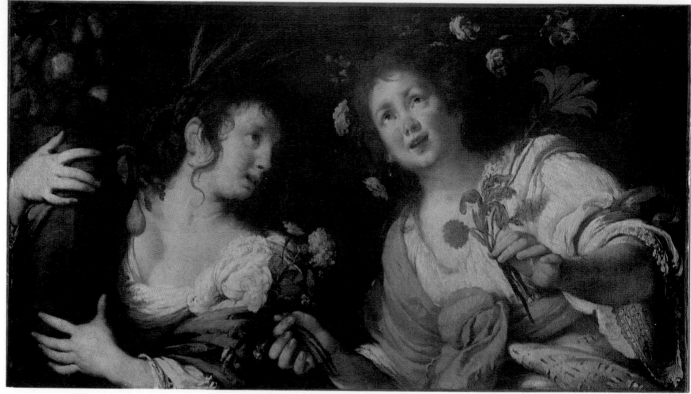

Summer and Spring.
BERNARDO STROZZI, 1581-1644.
Oil on canvas, 72 × 128 cm. Purchased in 1924.

Strozzi was born in Genoa where he became a Capuchin friar. He is sometimes, therefore, known as 'Il Cappuccino' ('the little Capuchin') or 'Il Prete Genovese' ('the Genoese priest'). While a friar, he also painted, and he was influenced by the pictures which Van Dyck and other Flemish artists painted in Genoa during his youth: his sense of colour is much more Flemish than Italian in tone. Strozzi left the Capuchin Order in 1641 and moved to Venice, where he remained until his death.

Showing personifications of Summer and Spring, this picture would have been painted as one of a pair representing the four seasons. Its pendant is now lost. Traditionally, Spring carries flowers and has garlands in her hair, whereas the attributes of Summer are corn and fruit. Summer here carries a cornucopia. From its shape, the picture was probably painted as an overdoor. It was purchased by Lord Powerscourt in Rome in 1836 and remained at Powerscourt until bought by the Gallery.

Strozzi's style, which is characterised by a very thick use of paint, is highly distinctive. His colour is very decorative, and in his subject pictures, such as this one, the people he portrays have a down-to-earth attractiveness that is quite distinct from glamour. In addition to paintings like this, he also executed portraits (there is one in the Gallery), designs for silverware and a number of paintings for churches.

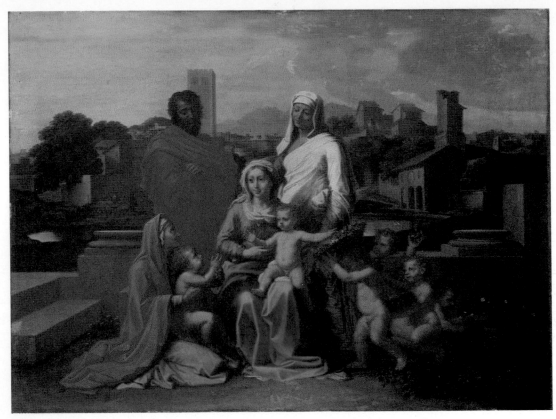

The Holy Family.
NICOLAS POUSSIN, 1594-1665.
Oil on canvas, 79 × 106 cm. Presented by Lady Milltown, in 1902.

Poussin was born in Normandy. After a time in Paris he settled in 1624 in Rome, where he worked mainly for the rest of his life. His paintings, more classical——that is, harmonically balanced——in style than those of any other painter in Rome during the 17th century, were favoured by a small group of learned collectors. This picture was painted in 1649 for one of his principal patrons, Pointal, a banker from Lyons who travelled in Italy. It was already at Russborough by 1826.

The Virgin and Child are seated with St Anne (the mother of the Virgin) behind them. The gaze of St Anne is directed lovingly at her daughter, St Joseph's at the Child. The infant John the Baptist is held by his mother, St Elizabeth, to be blessed by the Christ Child with a gesture that seems totally natural. Cherubs, introducing a pagan element, gather flowers and offer them to the young Christ. Human life is virtually excluded from the town in the background, and its peacefulness echoes the mood of quiet contentment found in the group of figures.

Poussin was deeply influenced by the remains of Antique sculpture and architecture that existed in Rome, and his study led to his own formal approach to composition in painting. The group of figures here is composed within various interlocking pyramids, and the buildings, block-like, are so proportioned that they create a perfect recession towards the horizon.

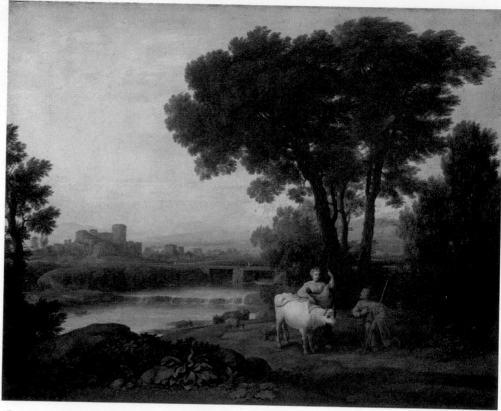

Juno confiding Io to the Care of Argus.
CLAUDE GELLÉE, called CLAUDE LORRAINE, 1600-1682.
Oil on canvas, 60 × 75 cm. Inscribed 'Claudio IV f. Roma 1660'. Bequeathed by Sir Hugh Lane in 1918.

Leaving France around 1612, Claude began his career as a pastry cook in the household of the Roman decorative painter Agostino Tassi. While influenced by the grandeur of Italian painting, he was also fascinated by the detailed landscapes and unusual lighting effects of the German painter Adam Elsheimer. By 1627, after two years in Naples, Claude had settled back in Rome, where he remained for the rest of his life. He retained strong links with his native France, however, and adopted the name 'Le Lorrain' after his birthplace.

Claude drew extensively from nature and carefully observed the subtle gradations of light in the Roman Campagna. He and his compatriot Poussin (see No. 24) shaped the classical landscape tradition in Rome. The softly poetic mood of his pictures evoked the pastoral idealism of Ovid and Virgil without the elaborate trappings of Roman history.

The tale depicted here is from Ovid's *Metamorphoses*, an important source of artistic inspiration. When Jupiter fell in love with the beautiful Io he transformed her into a cow, to protect her from the jealousy of his wife, Juno. Recognising her rival, Juno ordered her ever-watchful herdsman Argus, who had a thousand eyes, to guard the unfortunate maiden.

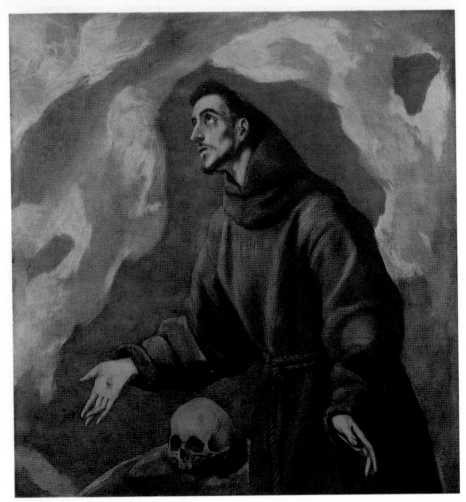

St Francis in Ecstasy.
DOMENIKOS THEOTOCOPOULOS, called EL GRECO, 1541-1614.
Oil on canvas, 114 × 104 cm. Presented by Sir Hugh Lane in 1914.

El Greco ('the Greek') was born in Crete, where his earliest influence was the powerful stylization of Greek icon painting. He then moved to Venice, where he was strongly impressed by Tintoretto's dynamic compositions and revolutionary use of light and colour. In 1570 he went to Rome and discovered the monumentality of Michelangelo: 'No worse fate can befall a figure', he declared, 'than that it should be undersized.' Finally, in 1577, he settled in Toledo, where he was admired by a small group of aristocratic and religious patrons.

El Greco was particularly fascinated by St Francis, and there is a strong parallel between his isolated life in Toledo and the Saint's retreat from religious pomp. A 13th-century visionary and reformer of the Church, St Francis led a life so closely imitative of Christ that during an ecstatic vision he received the wounds of the Crucifixion (the stigmata) on his own body. Originally loved for his simplicity, with the Counter-Reformation he took on a new role and became associated with intense spiritual experience, particularly in Spain. The prominently placed skull in the painting is a reminder of death; it was a popular attribute of ascetic saints during the Counter-Reformation.

El Greco's cold bluish tones and unnatural pinks and yellows can be as shocking as theatre make-up glimpsed in daylight, yet the contrasts between muted tones and vivid harshness give his free handling of paint and powerful compositions a dramatic excitement. He distorts his figures to convey intensity of emotion. Here the background has become an area of nervous shimmering colour which echoes the ecstatic feelings of the Saint.

Rubens was one of the most prolific artists who has ever lived. He was also a diplomat, and travelled widely. In his studio in Antwerp he employed a number of assistants, including Van Dyck, and painted pictures in all genres, as well as providing designs for other arts. This painting is somewhat unusual for Rubens in that it is so small.

Mary's discussion with Jesus was interrupted by Martha, who complained that her sister was gossiping and left her to do all the household chores. Jesus replied: 'Martha thou art troubled about many things; But one thing is needful: and Mary hath chosen that good part, which shall not be taken away from her.' Jesus points to Mary, who sits at his feet holding a book. Martha, busy with work, wears an apron. The servant in the background prepares a peacock for cooking.

The theme—contrasting active and contemplative, material and spiritual—became popular with artists in the 17th century, since it allowed them to paint a religious subject in a domestic setting. Great care has been taken here in the rendering of the fruit, flowers, animals and birds. Rubens painted the figures, and Jan Bruegel the landscape.

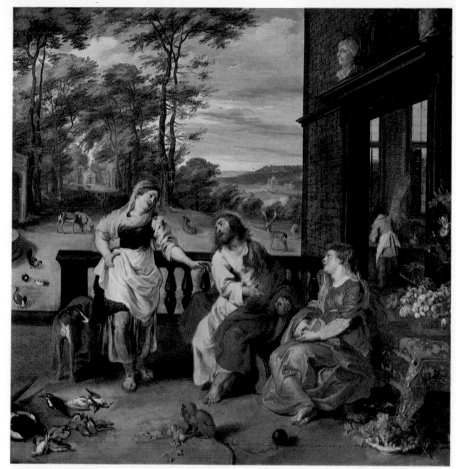

Christ in the House of Martha and Mary.
PETER PAUL RUBENS, 1577-1640 and JAN 'VELVET' BRUEGHEL 1568-1625.
Oil on panel, 64 × 61 cm. Bequeathed by Sir Henry Barron in 1901.

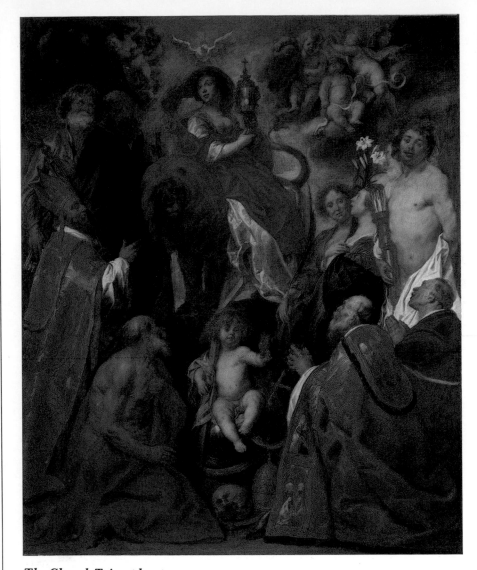

The Church Triumphant.
JACOB JORDAENS, 1593-1678.
Oil on canvas, 280 × 231 cm. Purchased in 1863.

Jordaens was born and died in Antwerp, where he at first worked as an assistant to Rubens, whose style influenced him in his early years. On the death of Rubens in 1640 Jordaens finished many of his paintings, and then became in his own right enormously successful. In later life his style became more classical and he himself more devout in his religious beliefs.

Dating from around 1630, this painting would have been executed as an altarpiece. Sometimes referred to as *The Triumph of the Eucharist*, it shows the Church, personified as a woman, seated on a lion which symbolizes her power. She holds aloft a monstrance with the Host. In the foreground are the four Latin Fathers of the Church: St Augustine (with bishop's mitre and crozier), St Jerome (almost naked, with his attribute of a skull), St Gregory (with papal tiara) and St Ambrose. Behind Augustine are St Peter (with keys) and St Paul (with book and sword). On the other side are St Sebastian (holding a quiver of arrows), St Catherine of Alexandria (with her wheel), and another saint who may be St Dorothy or St Rosalia. In the centre foreground is the Christ Child, depicted as Ruler of the World, seated on a globe encircled by a serpent. He holds a cross and a flaming heart, representing religious fervour. Above the figure of the Church is the dove of the Holy Ghost.

Murillo was born in Seville in southern Spain, where he worked all his life and founded an Academy of Painting. His paintings were immensely popular during his lifetime and have remained so throughout succeeding centuries, being much sought after by collectors in these islands. Murillo was known in Ireland within about thirty years of his death: his *Self-Portrait* (now in the London National Gallery) was purchased by Sir Daniel Arthur, 'a rich Irish merchant who died in Spain', and was the property of Sir Daniel's widow in Co. Cork by 1729, when the Earl of Egmont described it as by 'Monglio, a famous painter in Spain, little known here'.

St Joseph, his carpenter's bench on the left, is about to hand the Christ Child to the Virgin. Murillo paints the scene stripped of all affectation or rhetoric, as one of humble domesticity. The attitudes of the figures are both tender and simple, and are emphasised by the blank wall against which they are painted.

Because of his popularity (and painters as great as Reynolds and Gainsborough painted in homage to him), Murillo's work has been much copied and imitated. It is the cloying sweetness of these imitations that has led to the dismissal of Murillo himself as sentimental: in fact, his apparently effortless style conceals a very real talent for composition and colour, and the enduring appeal of his pictures is probably due to his genuine feeling for humanity.

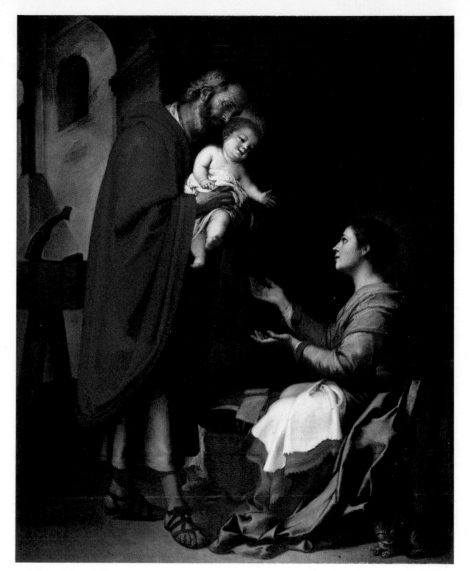

The Holy Family.
BARTOLOMÉ ESTEBÁN MURILLO, 1618-1682.
Oil on canvas, 205 × 167 cm. Purchased in 1962.

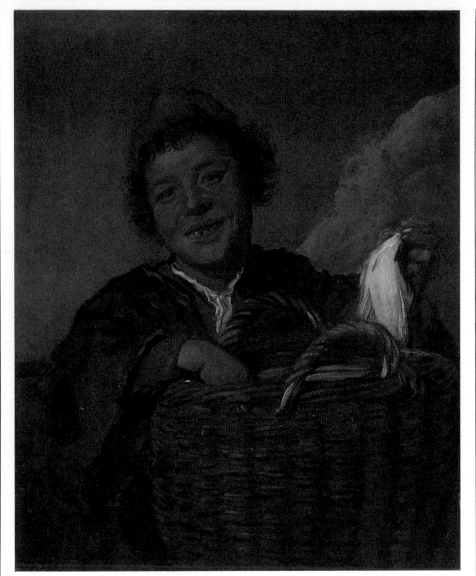

A Young Fisherboy of Scheveningen.
FRANS HALS, *c*.1580-1666.
Oil on canvas, 72 × 58 cm. Inscribed 'FH' (interlaced). Purchased in 1881.

Hals was born and worked mainly at Haarlem. Nothing survives of his juvenalia, but by 1616 he was confidently working on a large scale for his first group portrait of the St George Militia Company. Some time in the 1630s he visited the windswept beaches of Scheveningen near The Hague, a favourite spot for Dutch artists in search of everyday scenes, and there he painted a memorable series of pictures of fishermen and their families where any clear distinction between portraiture and genre is blurred.

This young fisherboy proudly displays a still dripping fish. Hals records with detachment his unremarkable features and irregular line of teeth, and makes no attempt to draw a moral lesson on the virtues of the outdoor life, as in contemporary engravings of such scenes.

Hals' skill is to suggest that immediacy of a sketch from life in a studio-painted picture. The most highly worked areas here are the face and the wicker basket. The latter ripples with colour and picks up the red of the boy's cap and cuffs. In contrast, his shoulder is only blocked in, his hand barely modelled and in need of some final sparkle. The structure of the face is articulated by angular strokes of paint on a general skin tone. Hals was perhaps too ambitious in his rendering of the fish, which dissolves in flecks of paint and looks almost like a feather. For the dunes behind, the paint is more solid, and Hals has caught the intensity of light before a storm.

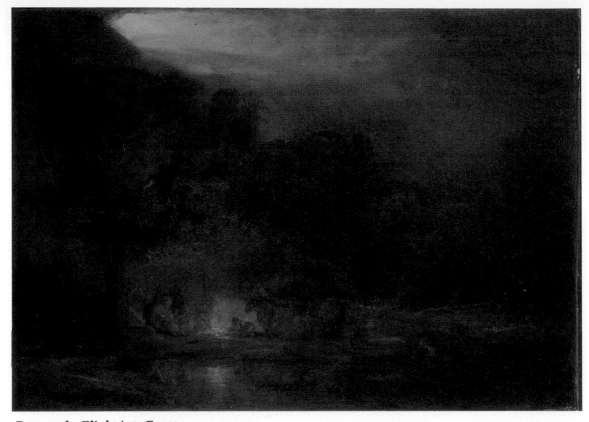

Rest on the Flight into Egypt.
REMBRANDT VAN RIJN, 1606-1669.
Oil on panel, 34 × 48 cm. Inscribed 'Rembrandt f. 1647'. Purchased in 1883.

Rembrandt was born in Leiden, the son of a miller. He first pursued an academic career, but then studied painting in Amsterdam with Pieter Lastman (see No. 34). In 1625 he set up as an independent artist in Leiden, and in 1631 he moved to Amsterdam, a larger and more lucrative market for his work, where his career blossomed. He married the daughter of a wealthy lawyer and purchased an expensive house which he filled with paintings and *objets d'art*. In 1642, however, his wife Saskia died, and

this tragic event, coupled with a change in public taste, led to a decline in Rembrandt's fortunes such that in 1656 he had to declare himself bankrupt.

This small panel is usually called the *Rest on the Flight into Egypt*, though the child seems too old to be the infant Christ. It has also been referred to as *Shepherds at Rest*, again a doubtful description. The composition is based on a *Rest on the Flight into Egypt* by Elsheimer, painted in Rome in 1609 and engraved by Hendrick Goudt in 1613; Rembrandt

most probably owned a copy of the print.

Whatever its subject, the picture must also be appreciated as a marvellously subtle and poetic 'night piece', a branch of painting best exemplified by Rembrandt's compatriot, Aert van der Neer. In an age when Dutch art was dominated by specialists—Vermeer for interiors, van Goyen for canal scenes, Hals for portraits—Rembrandt reigned supreme in his ability to create great masterpieces in every genre.

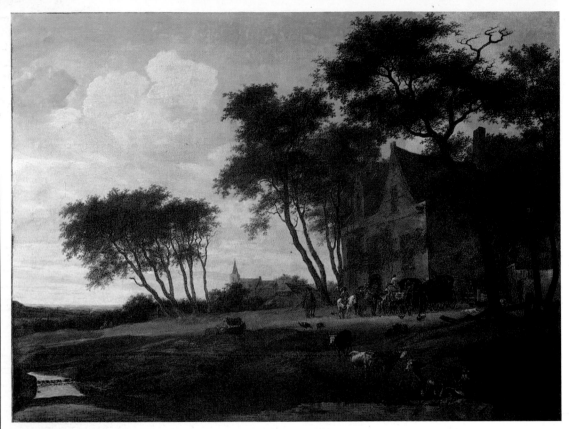

The Halt.

SALOMON VAN RUISDAEL, *c.*1600-1670.

Oil on canvas, 99 × 153 cm. Inscribed 'SR 1667'. Sir Henry Barron, Bequest, 1901.

In the 1630s a noted connoisseur, Constantin Huygens, wrote in his Autobiography that there were so many Dutch landscape painters that merely to list them would fill a book. Haarlem was a major centre for landscapists, and at this date Salomon van Ruisdael was exploring the surrounding countryside and recording delicate effects of light in near-monochrome painting. From the 1650s he broadened his range of subjects, painting still-life for the first time, and introducing more anecdotal interest into his landscapes.

The Halt is typical of Ruisdael's later work. The figures are more prominent than before and the central group particularly fine. The light from an Italianate sunset plays on the trees and brickwork. Cows ford a stream while hunters relax after the chase. A cavalier urinating at the right is shown in a matter-of-fact way, without satire. The carriage in the centre, playfully monogrammed 'SR',

recurs in pictures in London and Amsterdam.

The low viewpoint was much used in Ruisdael's early work, but the wide sweep of the river, the cattle, and especially the conversing sportsmen are all elements derived from the series of landscapes that Rubens painted around the Château de Steen near Antwerp some thirty years before. Ruisdael lacks Rubens' ability to blend detail within a panoramic view, and may have left the lifeless sheep to a studio assistant. He was by now competing with his nephew Jacob van Ruisdael, noted for the freshness and vigour in his landscapes, and may be imitating him in the groups of leaning trees, a hallmark of Jacob's.

De Heem followed Dutch custom by choosing one subject—the still-life—and specialising in it alone. He lived briefly in Utrecht and Leiden before settling in Antwerp, where, the contemporary art-historian Sandrart records, 'one could have rare fruits of all kinds . . . in finer conditions and state of ripeness to draw from life'.

A study in accurately observed light and colour, the painting also has a strong symbolic meaning. The main themes are that death is always near (*memento mori*), and that man's salvation is through the Passion of Christ. The transience of life was most popularly depicted through arrangements of fruit and flowers, in a community where horticulture was taken very seriously and exotic plants were valued as much as jewels. The cycle of man's life is traced from his fall in Eden (the snake) through the exuberance of youth and innocence (the Classical relief of cherubs) to his death (the skull). The cycle is echoed by the caterpillars, which become butterflies, symbolising the release of the soul from the body, and the corn, which must be buried in the ground before it can spring to life again. The Passion of Christ is illustrated by the Crucifix and recalled by the pomegranates, which bleed from ripeness, and the single red flower. Man's salvation is through the bread and wine set in the lower left corner.

The painting's recent cleaning shows de Heem's delight in the translucent coolness of the grapes contrasted with the rich syrupy pomegranates. He reminds us of eternity, but also of the rich and vital beauty of the moment.

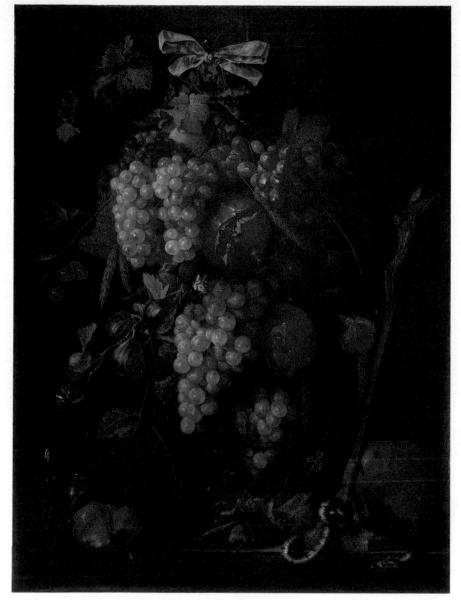

Fruit Piece with Skull, Crucifix and Serpent.
JAN DAVIDSZ DE HEEM, 1606-1684.
Oil on canvas, 84 × 64 cm. Inscribed 'J. DE heem f.A°. 1653'. Purchased in 1863.

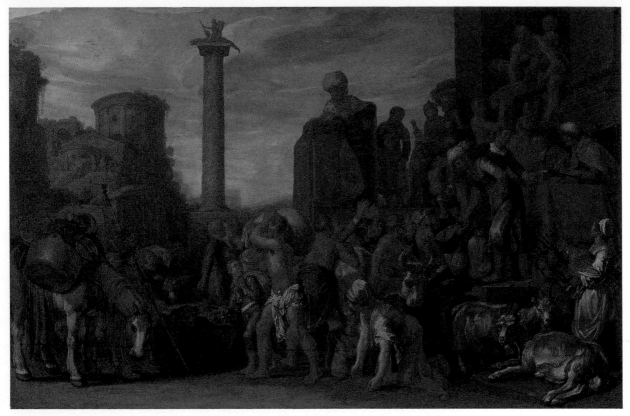

Joseph selling Corn.
PIETER LASTMAN, 1583-1633.
Oil on panel, 58 × 87 cm. Inscribed 'P Lastman fecit 1612'. Purchased in 1927.

Lastman was born in Amsterdam. After a time in Rome he returned to his native city about 1607 to become one of the most important painters of religious and mythological pictures in Holland. In 1624 he had as his pupil Rembrandt, who copied this picture in a drawing which is now in Vienna. Lastman's paintings are generally small but they contain numerous figures and are filled with incident and meticulous detail, such as the pots and pans on the horse at the left.

Joseph, sold into slavery in Egypt by his brothers, interpreted a dream of Pharaoh that seven years of good harvests would be followed by seven years of bad. When this happened, since the produce of the good years had been stored the Egyptians were saved from starvation. Jacob, the father of Joseph, sent his other sons into Egypt to buy corn, which they did unwittingly from their own brother. In our painting, while Joseph's brothers pay gold for their corn, others bring animals and offer them in exchange to Joseph, who stands silhouetted at the top of the steps. He wears a turban and the gold chain awarded him by Pharaoh. Although scenes from the life of Joseph are quite common in art, this episode is relatively rare.

Lastman must have remembered affectionately his years in Rome. The temple on the hilltop is Roman and similar, for example, to the Temple of Vesta at Tivoli; and the column is a Roman triumphal column, though the artist has Christianised it by placing St Theodore on the top.

Troost was the most talented of all Dutch 18th-century portraitists. His work is often compared to that of Hogarth (see No. 41): both artists painted genre scenes of contemporary life with a strong element of social satire, although Troost was never so bitingly savage as Hogarth.

This portrait shows two members of an Amsterdam family, Jeronimus Tonneman and his son, who was also called Jeronimus. The father was 49 when the picture was painted, and his son about 24. We know where the family lived in Amsterdam, but the room depicted is probably imaginary and conceivably much more elegant than their home. The book on the table is Karel van Mander's *Het Schilderboek* ('The Painter's Book') of 1604, to this day the most authoritative source book on the painters of Northern Europe. The flute which the young man plays is a standard one-keyed instrument of the time.

The elder Tonneman was an important patron of Troost and owned several of his paintings. In this picture Troost shows him very much as a connoisseur of the arts. There is also an element of wit: the stucco roundel partly visible over the chimneypiece behind the flautist shows Mercury killing Argus, which he did after lulling him to sleep with music (see No. 25). The other relief shows the winged and aged figure of Time unveiling Truth. A year after the portrait was painted the younger Jeronimus stabbed his mistress with a pair of scissors and fled Holland as a midshipman on a voyage to the East Indies.

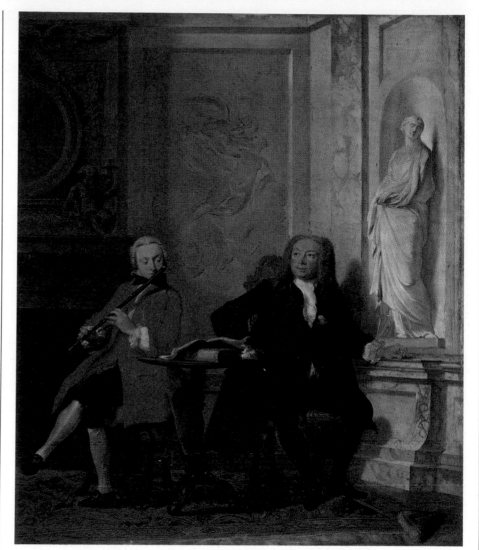

Portrait of Jeronimus Tonneman and his Son ('The Dilettanti')
CORNELIUS TROOST, 1697-1750. Oil on panel, 66 × 56 cm. Inscribed 'C. Troost 1736'. Purchased in 1900.

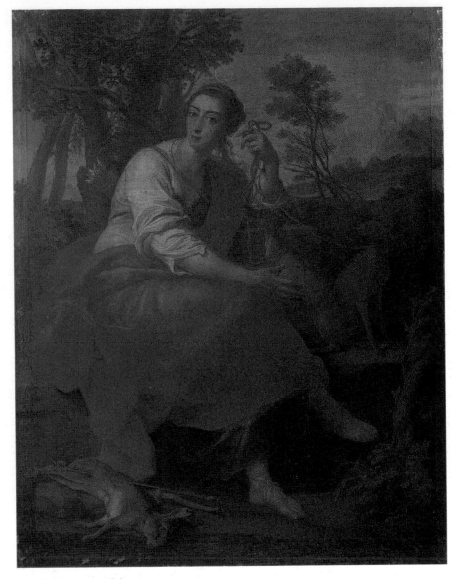

Lady Leeson as Diana.
POMPEO BATONI, 1708-1787.
Oil on canvas, 48 × 38 cm. Presented by Lady Milltown, in 1902.

Batoni, who came from Lucca in northern Italy but worked most of his life in Rome, is famous for his portraits of the Irish and English who made the Grand Tour in the 18th century. There are three other portraits by him in the National Gallery of Ireland, among them one of Pope Pius VI which was presented to the Gallery by Robert Tighe of Inistioge in 1875.

It was part of the education of a gentleman to travel on the Continent in youth, usually in the company of a tutor. In places such as Rome, a *cicerone* (generally an expatriate resident) would be employed to act as guide. It was not unusual for the Grand Tour to last as long as two years, and part of the ritual was visiting the opera, museums, archaeological excavations, and dealers in pictures and antiquities.

Joseph Leeson, later 1st Earl of Milltown, made the Grand Tour in 1744-45 and again in 1750-51, and on his visits to Italy purchased pictures, statuary and furniture for Russborough, the house that he built in Co. Wicklow. (A letter dated 1745 describes 'many statues, pictures, etc., of Mr Leeson a rich Irishman' as having been shipped from Italy but 'taken by the French'). On his first visit he sat for his own portrait to Batoni and on his later journey he brought with him a miniature or drawing of his wife, from which he commissioned Batoni to paint this picture. It shows Anne Leeson as Diana the huntress, Roman goddess of the chase. She wears a crescent moon on her head and is pictured with her hounds, quiver and arrows.

Tiepolo's native Venice provided a wealth of artistic influences from which he evolved a style that made him the most sought-after decorative painter of his age. In 1721 he married Cecilia Guardi, the sister of the painter Francesco, and so united the two most important artistic families of 18th-century Venice. Their son was also a painter. Tiepolo's style recalled the sumptuousness of Veronese (see No. 19) and the brilliant illusionism of Tintoretto, and contributed a light capriciousness which was all his own. In 1750 he was called to Würzburg to decorate the Residenz, and from 1762 until the end of his life he worked in Madrid on the Royal Apartments. There he influenced the young Goya by his imaginative mastery of line, but his popularity declined with the approach of Neo-Classicism.

This small picture is an oil sketch for a larger work, probably a ceiling, which was never carried out. Ever since the dogma of the Virgin's purity was defined by the early Church it has given rise to elaborate symbolism. Tiepolo's allegory celebrates her birth without original sin and her triumph over the Fall of Man, which is represented by the serpent threatening to encircle the globe. The crescent moon and the crown of stars were described in the vision of the Tiburtine Sibyl, who saw a woman clothed in the sun and with the moon at her feet. The mirror, held like a talisman against sin, comes from the Song of Songs, in which the Shulamite maiden had long been identified with the Virgin.

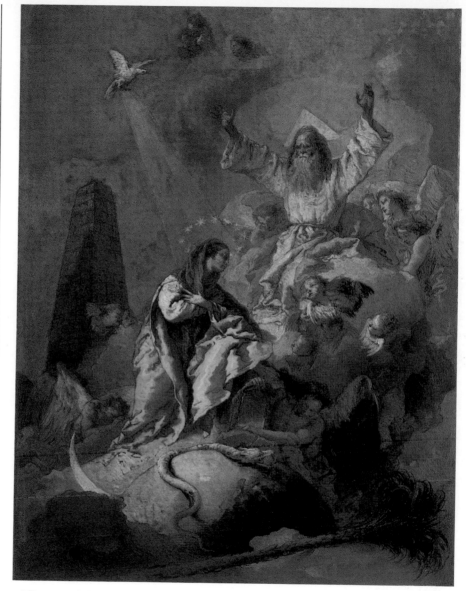

Allegory of the Immaculate Conception.
GIOVANNI BATTISTA TIEPOLO, 1696-1770.
Oil on paper, laid on canvas, 58 × 44 cm. Purchased in 1891.

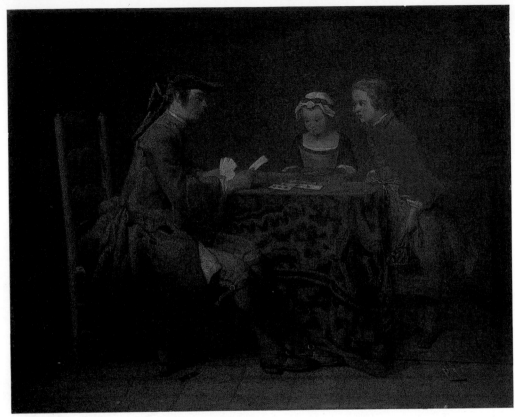

Les Tours de Cartes.
JEAN BAPTISTE SIMÉON CHARDIN, 1699-1779.
Oil on canvas, 31 × 39 cm. Purchased in 1898.

Chardin came from a poor Parisian family, and began working under the painter Cazes. In 1724 his father unwittingly hampered his career by enrolling him in the Fraternity of St Luke, a body which had been superseded by the Académie Française. Lacking a classical education, he turned to still-lifes and genre painting, which enjoyed a vogue in mid-18th-century France. His early collaboration with Nicolas Coypel, who painted in a naturalistic Dutch manner, was an important influence, and it was for a still-life that Chardin was finally accepted by the Academy in 1728. His sensitive observation of character and domestic detail took French genre painting to a new height, although financial security eluded him and for the last eight years of his life he turned to the latest artistic fashion, pastel portraiture.

With an intimacy that avoids sentimentality Chardin has portrayed a rather worldly young man mystifying two children with a card trick. His mockingly serious expression contrasts with the naïve young girl, who timidly places her hands on the table edge, and the boy who watches him, aware of some deceit.

Chardin's technique was unconventional and fascinated his contemporaries: the influential critic Diderot recorded that 'he has a method of painting peculiar to himself and uses his thumb as much as his brush'. He applied a thin layer of paint over areas of the picture so that the colours beneath were partly visible, introducing a rich warmth of colour and texture.

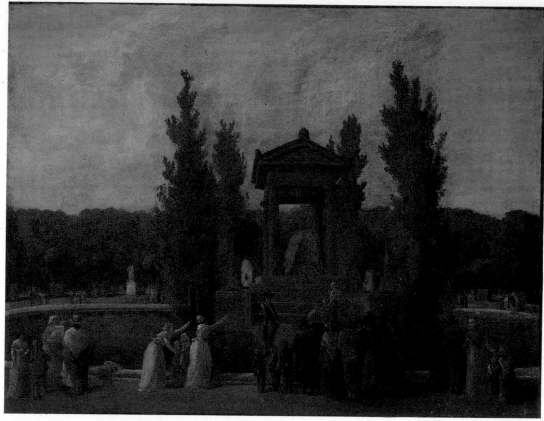

The Apotheosis of Jean-Jacques Rousseau.
HUBERT ROBERT, 1733-1808.
Oil on canvas, 62 × 81 cm.
Inscribed 'H. ROBERT 1794'. Purchased in 1927.

In 1754 the young Robert travelled from his native Paris to Rome, where the landscapes of Claude and Poussin (see Nos. 24, 25) made a deep impression on him. He spent twelve years there, working with Panini and Piranesi, and visited southern Italy and Sicily with his close friend Fragonard. He enjoyed juxtaposing rustic scenes and classical ruins, and was one of the last exponents of this delicate fashion, although he was recognised by Diderot as a forerunner of the Romantic response to nature.

Rousseau's ideas on education and the natural dignity of man were influential throughout late 18th-century Europe. When he died in 1778 at Ermenonville a monument to him, designed by Robert, was erected on the nearby Poplar Island. France was still surging with the Revolutionary spirit when in 1794 Rousseau's body was transferred from Ermonville, to the Paris Panthéon, Robert celebrated the event with two paintings, of which this is one. He indicates Rousseau's glorification, in a shrine recalling his own monument, simply by the delicate halo which floats above the pale blue pall.

The breeze rustling through the poplars and the silvery light evoke Rousseau's love of nature, while the ragged and fashionable figures who gather to honour his memory recall his respect for all humanity. Only the armed men give a faint air of disquiet. During the Revolution Robert himself had only escaped the guillotine when someone of the same name was executed by mistake.

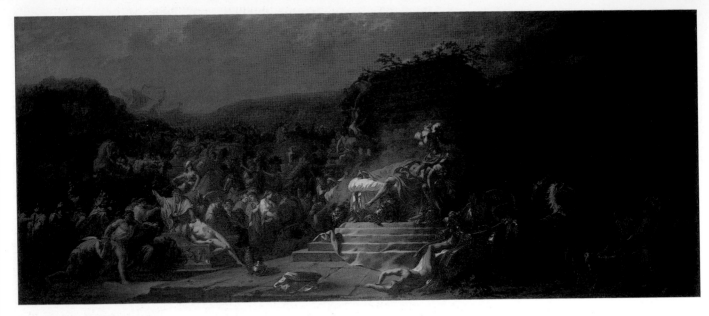

The Funeral of Patroclus.
JACQUES LOUIS DAVID 1748-1825.
Oil on canvas, 94 × 218 cm. Inscribed 'J.L. David f. Roma 1779'. Purchased in
1973.

In 1778 David was studying at the French Academy in Rome and he sent back to Paris this fully worked sketch (with drawings from the life class) as evidence of his progress. It was dated when later exhibited in Rome.

The Funeral of Patroclus is the climax of Homer's epic poem, the *Iliad,* describing the Greek war against the Trojans. David captures the richness and savagery of Homer's story and illustrates the republican virtue of sacrifice for one's country. After ten years of fruitlessly besieging Troy the semi-divine prince Achilles had a petty dispute with the leader, Agamemnon, and withdrew from the fighting. In order to rally the army and save the fleet, Achilles' young friend Patroclus impersonated him, and was successful until Apollo intervened and aided Hector to kill him. Before mourning Patroclus, Achilles avenged him by killing Hector and dragging his body behind a chariot (centre). A towering pyre of oak trees is set against an animated frieze of the Greek camp. A chorus of mourners is present, and priests are leading on the first sacrificial animals.

The bodies on the pyre and the men whose throats are being cut are twelve Trojan princes, captured for just this purpose by Achilles.

The picture was not well received in Paris. There was 'too much flickering in the highlights and too overt echoes of well-known groups'. (The central group is for example much indebted to an earlier picture of the same subject by Gavin Hamilton, now in Edinburgh). Within a few years David abandoned such freedom and bravura for the austere style of his famous *Oath of the Horatii.*

Hogarth, who lived all his life in London, may be seen as the first great native English painter. His colour and use of paint are exquisite, and his portraits are outstanding in both composition and characterisation. Without in any way glamourising his sitters, he created an image of 18th-century England and the English that is quintessential. He is best known for the engravings after his satirical subject pictures, notably *The Rake's Progress* and *Marriage-à-la-Mode*, which invariably contain some moral.

The children in this portrait, probably painted in the 1740s, are reputedly the Chief of the Clan Fingon, William Mackinnon, and his sister, whose family lived at Binfield, Berkshire. They are depicted on the terrace of a house where the boy has been reading to his sister. Their interest in study, however, is not as serious as it might be: the girl has been playing with the shells gathered in her apron, and the attention of both children has momentarily been arrested by a butterfly landing on a sunflower. The boy attempts to catch it. The innocence of childhood, which will shortly give way to the cares of adult life, is very much what Hogarth intends to convey in the picture: the butterfly will fly away; the sunflower, which itself always turns towards the sun, is in full bloom but it too will not last.

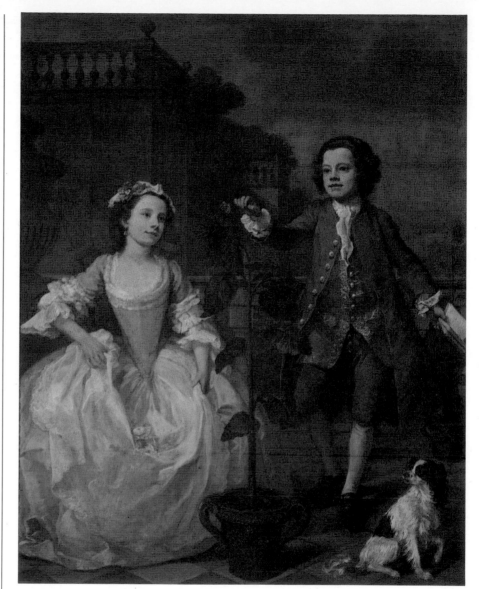

The Mackinnon Children.
WILLIAM HOGARTH, 1697-1764. Oil on canvas, 180 × 143 cm.
Bequeathed by Sir Hugh Lane, in 1918.

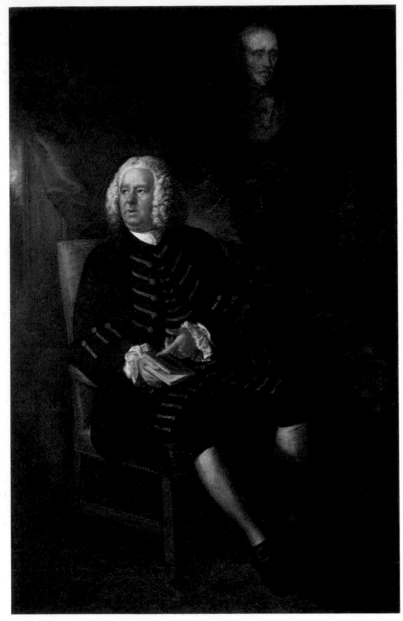

Portrait of James Quin.
THOMAS GAINSBOROUGH, 1727-1788.
Oil on canvas, 231 × 150 cm. Purchased in 1904.

Gainsborough moved from his native Suffolk in 1759 to the fashionable spa town of Bath, and there divided his time between socialising and portrait painting. A study of works by Van Dyck and Titian in nearby country houses gave him the confidence to work on a larger scale. He portrays his sitters as dignified but relaxed, with a greater sensitivity to gesture and dress than his London rival Reynolds.

James Quin (1693-1766), a famous tragic actor, was born in London, the illegitimate son of a barrister and grandson of a Dublin Mayor. He was educated in Dublin, and had graduated from Trinity College before a lost inheritance and an interest in acting led to his first appearances in the notorious Smock Alley Theatre. He was apparently vain and quarrelsome: in 1718 he escaped with only a fine after killing two fellow actors. In the 1750s Quin retired to Bath but continued performing privately. He died three years after this picture was painted in 1763.

The actor is probably seated in Gainsborough's studio at No. 17 Royal Circus, appropriately below a bust of Shakespeare. Caught in mid-explanation, he could be easily mistaken for a writer or politician, an image far removed from less flattering theatrical portraits by artists such as Hayman. The composition is taken from a popular engraving of 1746 by Hogarth, showing the Scottish traitor Lord Lovat. Quin may have deliberately chosen this conceit, even dressing in period clothes, as he plays a final role. In his will, Quin left £50 to 'Mr Thomas Gainsborough, limner, now living at Bath'.

By his art and as first President of the Royal Academy, Reynolds more than any other painter raised the standard and status of British painting. As a young man he travelled in Italy. Setting himself up in London in 1752, he earned his living by painting portraits; but he made of portraiture something much grander than hitherto, by painting his sitters in poses inspired by Old Master paintings and antique sculpture (see No. 45). This Irish country gentleman has been painted with an *éclat* worthy of a Renaissance prince; and the portrait, instead of being a simple record of an arrogant man, becomes a composition in its own right.

Charles Coote, 1st Earl of Bellamont (1738-80), of Bellamont Forest, wears the collar and star and robes of the Order of the Bath, of which he had been made a Knight in 1772, a year before the picture was painted. On the left in his standard bearing his crest which, not surprisingly, is a coot. According to *The Town and Country Magazine* for 1786, Lord Bellamont's 'ruling passion was vanity'. He returned from the Grand Tour 'a complete macaroni; but though in person and equipage every appearance was gaudy and in the extreme of fashion, yet in conversation he delighted by the brilliancy of his wit'. His native Co. Cavan he described as 'all acclivity and declivity without the intervention of an horizontal plane'.

The portrait was shown at the Royal Academy in 1774. Together with its pendant, which showed Lady Bellamont, it hung at Bellamont Forest until its purchase by the Gallery.

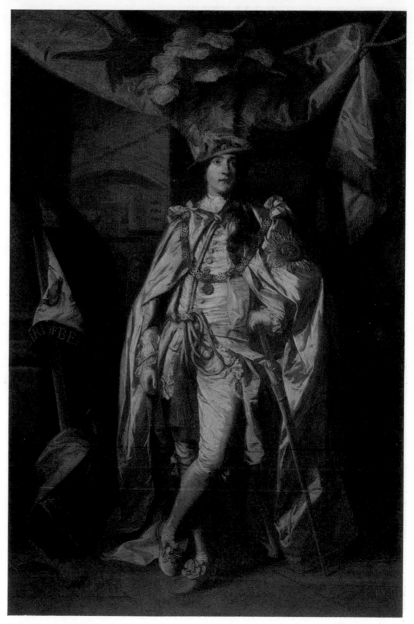

The Earl of Bellamont.
JOSHUA REYNOLDS, 1723-1792.
Oil on canvas, 245 × 162 cm. Purchased in 1875.

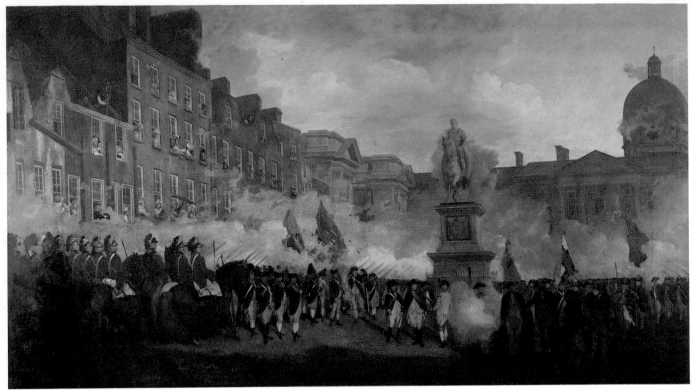

The Dublin Volunteers in College Green, 4th November, 1779.
FRANCIS WHEATLEY, 1747-1801.
Oil on canvas, 175 × 323. Presented by the 5th Duke of Leinster, in 1891.

Wheatley became a member of the Royal Academy in 1791, after many vicissitudes. Perhaps a pupil of Zoffany, he was a popular painter of portraits and of sentimental scenes of rural and domestic life. In 1779 debts and the scandal of his involvement with the wife of another painter, John Greese, were such that, as a contemporary delicately explained, 'he was induced to visit Dublin'.

When Wheatley arrived, passing Mrs Greese off as his wife, he found Ireland in an excited and patriotic mood. England was at war with France and her American colonies and partly as a result Ireland was suffering grave trade restrictions. Local militias were spontaneously raised, commanded by the landed gentry. Henry Grattan, Speaker of the Irish House of Commons, had demanded free export trade, and the Volunteers accompanied him to Dublin Castle: alarmed by this show of strength, the English Parliament quickly repealed the restrictive trade laws.

Wheatley was present at this gathering of the Volunteers to commemorate the birthday of William III, whose statue by Grinling Gibbons stood before Trinity College. He hoped to have an engraving made of the painting which would have sold well amid such patriotic fervour, so he took particular care with the military insignia and the portraits of those he included. The Duke of Leinster stands in the centre; on the left is Sir Edward Newenham; and in a prominent position, under a green parasol, is Princess Daschkaw, a lady of honour to the Empress Catherine the Great of Russia.

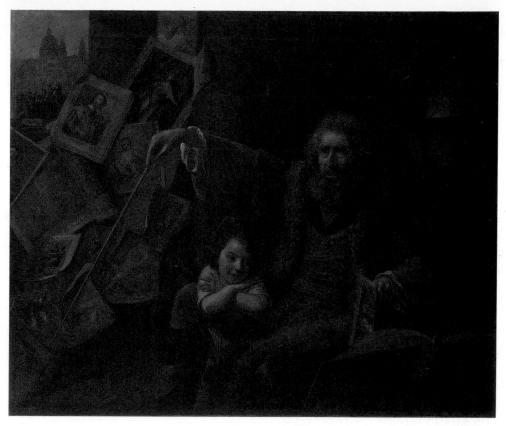

The Conjurer.
NATHANIEL HONE,
1718-1784.
Oil on canvas, 145 × 173 cm.
Purchased in 1966.

Hone, the son of a Dublin merchant, made his reputation as a miniature painter and settled in London. He was a founder member of the Royal Academy in 1768, but preferred Dutch painting to the work of Italians and Flemings extolled by Sir Joshua Reynolds, the first President.

This picture, which today seems innocuous enough, caused a scandal in its time. An aged conjurer is creating a picture (bottom left) from a shower of Old Master prints, provided by the devil who flies away in the centre. St Paul's Cathedral can be seen through a window, a backcloth for a group of artists smoking and drinking at a table. Originally, however, this section contained seven nudes, including one in boots waving a paintbrush and palette. Angelica Kauffman, the leading woman portrait and decorative painter, saw a resemblance to herself and insisted that the picture be withdrawn from the 1775 Academy annual exhibition. Hone painted out the nudes (still visible in x-rays) but was unable to placate her.

The painting's full title was *The Picto-rial Conjurer, displaying the whole art of optical deception.* Several of the prints had been the basis of well-known portraits by Reynolds, and contemporaries were quick to see that he was the true subject of Hone's attack. The model for the conjurer was George White, (one of Reynolds' favourites) posed in imitation of the *Apollo Belvedere.* He holds a print of Raphael's *Diadem Madonna,* where Christ, or truth, is revealed to mankind. The owl, a symbol of wisdom in Antiquity, was a sign of folly in Dutch art. The insubstantial creations of the artists (turning to smoke from their brushes) may be a comment on the scheme by Reynolds and his circle to decorate the interior of St Paul's.

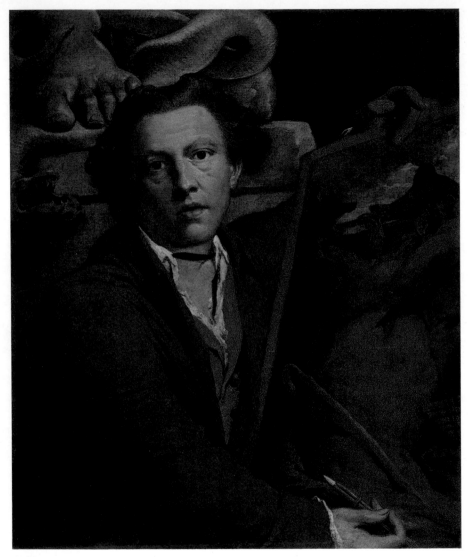

Self-Portrait.
JAMES BARRY, 1741-1806.
Oil on canvas, 76 × 63 cm. Purchased in 1934.

Barry was born in Cork and was largely self-trained. In Dublin he met Edmund Burke, who took him to London in 1764 and introduced him to his own circle of friends, among them Reynolds. On Reynolds' advice, Barry went to Italy, where he spent about five years painting and studying the works of the Old Masters. Returning to London, he determined to devote his talents to history painting. Others in England before him had had similar ambitions, notably Hogarth and Reynolds; but British patrons preferred their Old Masters to be foreign, and commissions to contemporary painters were almost exclusively for portraits and landscapes. Barry ended life a disappointed man. He became Professor of Painting at the Royal Academy, but because of his verbal attacks on fellow-members he was expelled, and later died in poverty. His greatest pictures are those which he painted in the Royal Society of Arts in London in the 1780s. A self-portrait in one of these, *The Victors at Olympia*, formed the basis for this picture.

Barry portrays himself as Timanthes, a Greek painter of the 4th century BC. He holds in his hand a painting of a Cyclops sleeping, based on a description of a picture by Timanthes. The statue partly visible shows Hercules trampling on the serpent of envy.

Pliny described Timanthes as an artist whose ideas about painting, being greater than his talent, were not always understood, and Barry's self-portrait is therefore an illustration of his own predicament as a painter. The statue implies that Barry had subdued his own envy of his more successful contemporaries (which, of course, was untrue). The picture, probably painted in 1803, shows him as a much younger man.

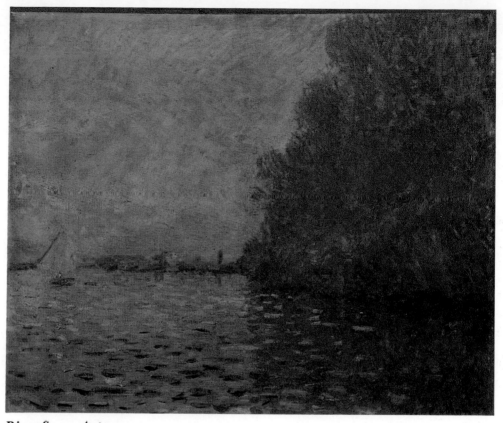

River Scene, Autumn.
CLAUDE MONET, 1840-1926.
Oil on canvas, 55 × 65 cm. Bequeathed by Edward Martyn, in 1924.

Monet, born in Paris, can be called the founder of Impressionism: it was a picture by him, entitled *Impression, Sunrise,* which he showed in Paris in 1874 at what is now referred to as the First Impressionist Exhibition, that unwittingly gave its name to the whole style. The term, meant at first as an insult, is, however, apt, for the Impressionists sought to render in paint the sensation of light rather than the precise form of things. Impressionism was one of the most important movements in the history of art, which by challenging traditional ideas of colour and form led to the freedom which all artists have subsequently enjoyed. Unlike many of the other Impressionist painters, Monet remained faithful to the style throughout his long life.

The scene shown is probably on the River Seine near Paris, where Monet often worked. The rust-coloured trees on the right, which are reflected in the water, indicate that it is autumn. The movement of water, cloud and trees is conveyed by the application of the paint in strokes of strong colour which, merging in the viewer's eye, create a convincing whole. The water on the left is painted in different colours from that on the right, because Monet observed that the shadow cast by the trees effected a subtle change. Absorbed by the play of light, he paints in bold strokes of white a flickering reflection of the sailboat on the left.

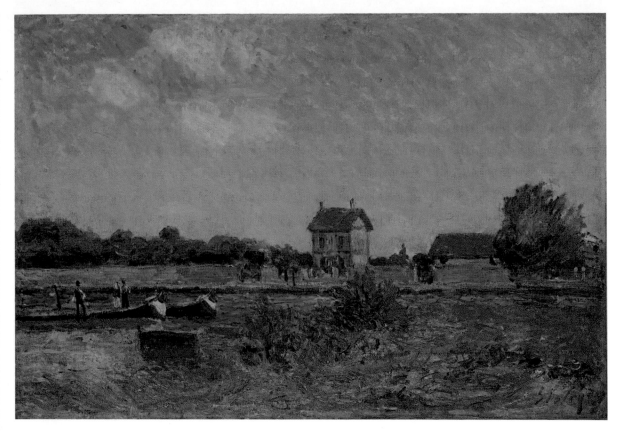

Bords du Canal du Loing à Saint Mammes.
ALFRED SISLEY, 1839-1899.
Oil on canvas, 38 × 56 cm. Inscribed 'Sisley 88'. Purchased in 1934.

Sisley was born in Paris of English parents. In 1862 he entered the Academy of Charles Gleyre, where he met Monet, Renoir and Bazille, young artists who shared his views on painting and with whom he was to form a lasting friendship. He painted as an amateur until 1870, when the Franco-Prussian War ruined his father's business. From then until his own death from cancer, he painted for a living—a meagre living, sadly. Without the patronage of Durand Ruel, the first dealer who supported the Impressionists, he would have become destitute.

This small painting, radiant with light, depicts a scene on the Canal du Loing, south-east of Paris. It is tightly composed, with delicately balanced accents of form and colour. The technique which Sisley employed in rendering this image of a glorious summer's day is typical of his style. He applied differing forms of brush stroke over the various areas of the canvas in response to the changing nature of light and the materials it illuminated. The sky is smooth, the wall and house are firmly registered, while the foreground is alive with freely applied splashes of paint, resembling a Jackson Pollock. Sisley explained this aspect of his art to the critic Adolphe Tavernier: 'You see I am in favour of different techniques within the same picture . . . The sunlight, in softening the outlines of one part of the scene, will clarify and illuminate another, and these effects of light which seem real in a landscape ought to be interpreted in a material way on the canvas.'

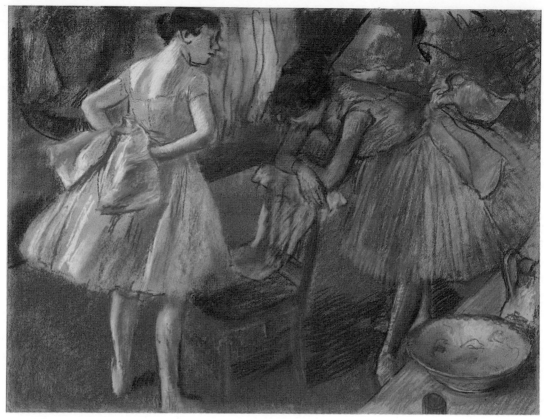

Ballet Girls.
EDGAR DEGAS, 1834-1917.
Pastel on paper, 48.5 × 64 cm. Inscribed 'Degas'. Bequeathed by Edward Martyn, in 1924.

Degas, the son of wealthy parents, studied at the Ecole des Beaux Arts in Paris, where he received a solid grounding in the academic tradition of painting, with an emphasis on drawing and technique. Soon, however, he associated himself with the avant-garde. He showed his work at the first Impressionist exhibition in 1874, and thereafter, working alongside the Impressionists, developed his own highly individual and immensely attractive style. Most of the Impressionists, such as Monet and Sisley (see Nos.

47, 48), worked out of doors. Degas was different, although, like them, he painted contemporary rather than historical subject-matter. Working largely indoors, he favoured as subjects ballet girls, cabaret artists and women bathing, frequently depicted from unusual viewpoints.

Degas shows us two ballerinas in their dressing room. The simple wooden chair and the rudimentary basin and jug are in marked contrast to the elegance of the dancers and their dresses. As in other

pictures on this theme, Degas makes a point of contrasting the glamour of the dancers' public life with the dimness of their backstage existence.

Degas was a superb draughtsman and his pictures exhibit a positive exuberance in the use of line. He constantly experimented with technique, and finding that the dry medium of pastel offered him greater freedom than oil used it more and more often in his pictures. Edward Martyn purchased *Ballet Girls* in 1886, soon after the artist painted it.

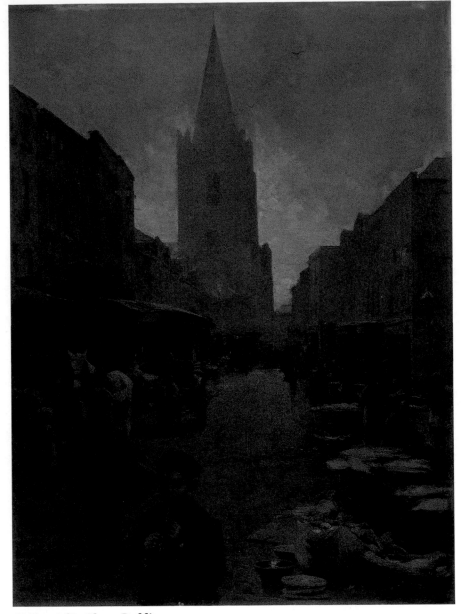

Osborne was born in Dublin and attended the Schools of the Royal Hibernian Academy. In 1880 he went to study at the Antwerp Academy, where he remained for about two years, and subsequently worked in Brittany among a group of English artists who were painting in a realist vein. Thereafter he spent his life between England and Ireland, where he died in Dublin of pneumonia at the age of 44. The attraction of his work is that he combined the lyrical response to nature and landscape of the Impressionists with a compassionate feeling for humanity. During his life his subject pictures, like this one, often remained unsold and he was obliged to earn his living by portrait painting.

Osborne called his picture *Near St Patrick's Close, an old Dublin Street*. The view, which is exact, is looking south along what is now Patrick Street, towards the Cathedral. All the houses on the left have been demolished and the Iveagh Buildings and the Cathedral Park replace them. The four houses on the extreme right, beyond the fish stalls, are gone to provide a parking lot; beyond them is what is now McDonald's pub.

The painting was unsuccessfully exhibited in 1887 at the Royal Academy in London and at the Walker Art Gallery, Liverpool. It found a buyer at the Royal Hibernian Academy in the following year, when the price was lowered to 40 guineas. Today Osborne is firmly established as a major figure in the history of Irish painting.

St Patrick's Close, Dublin.
WALTER OSBORNE, 1859-1903.
Oil on canvas, 69 × 51 cm. Inscribed 'Walter Osborne. 1887.' Purchased in 1921.